Stephen Waddell: Dark Matter Atlas

Vancouver Art Gallery

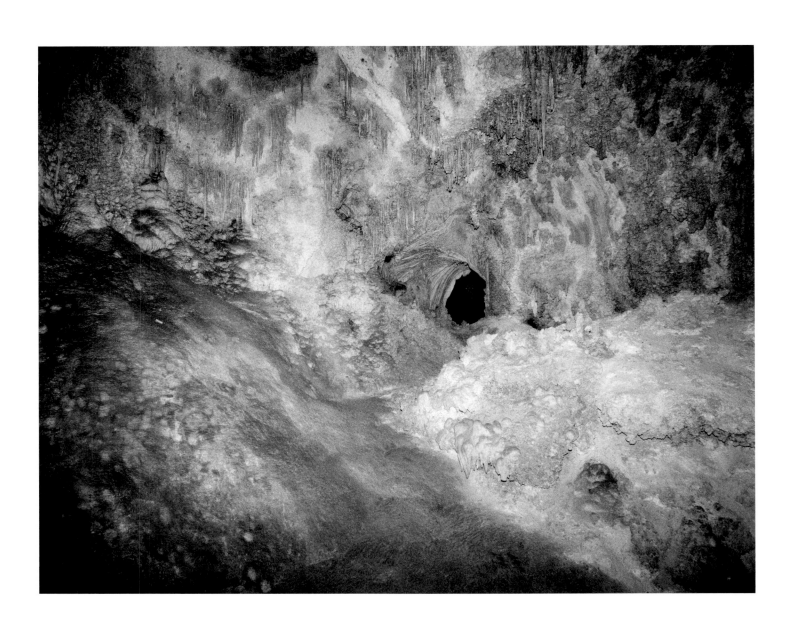

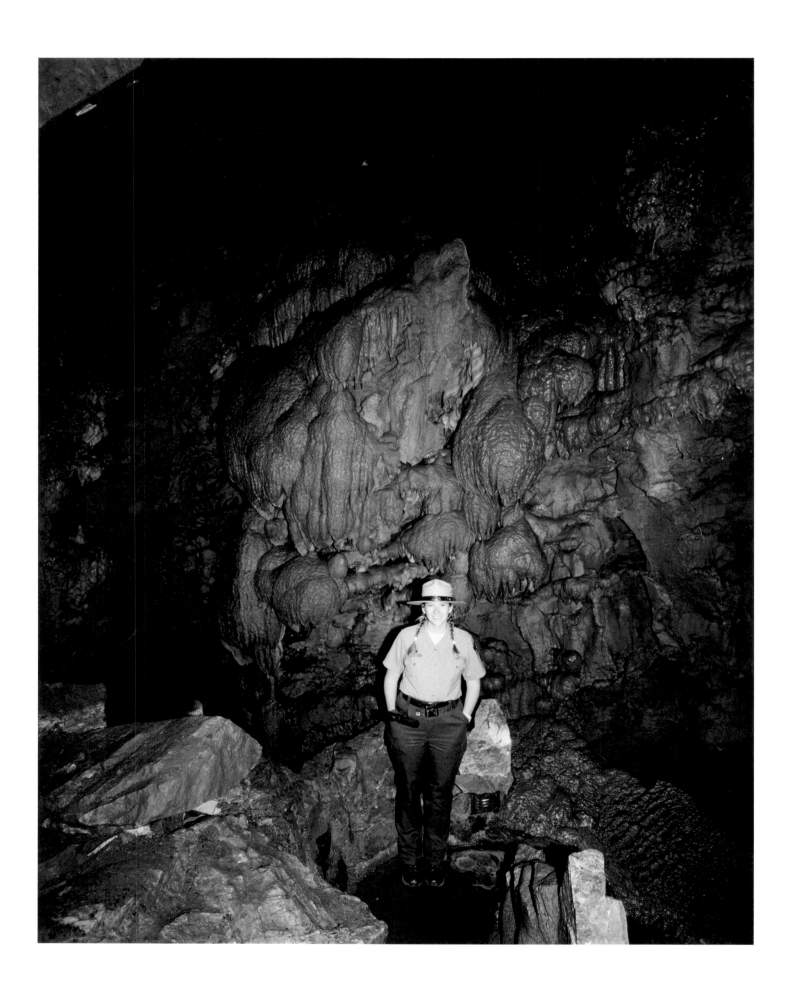

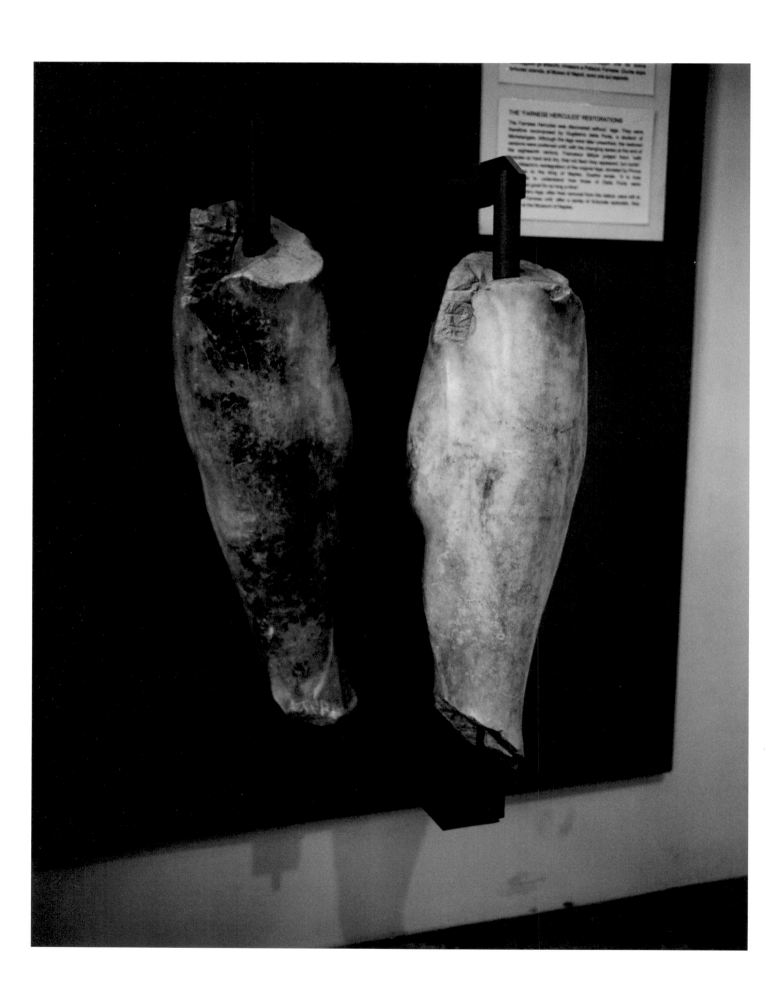

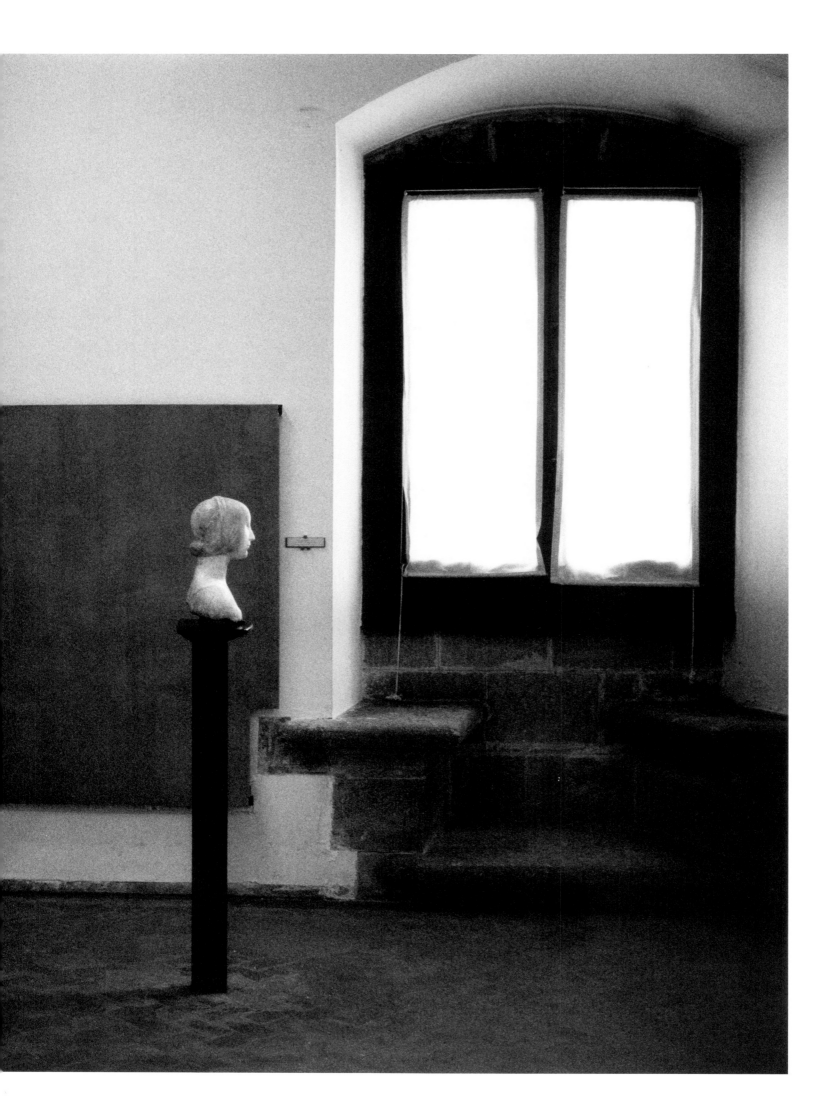

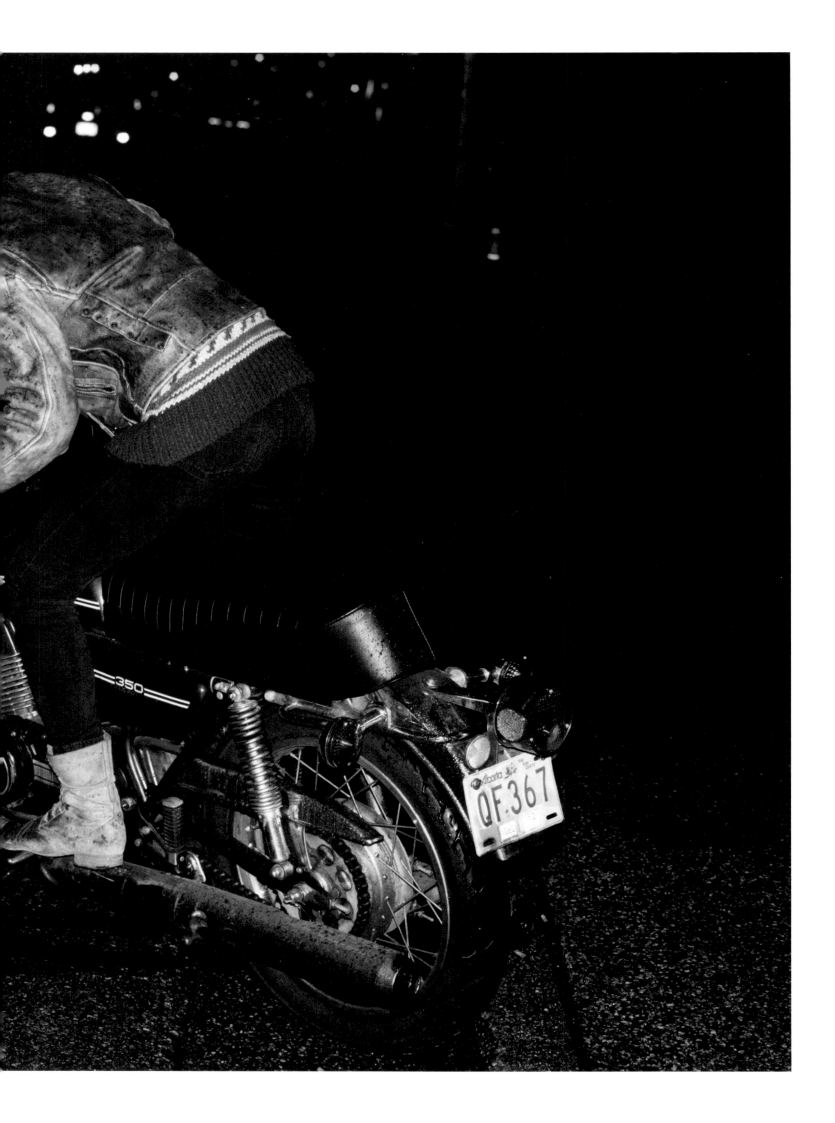

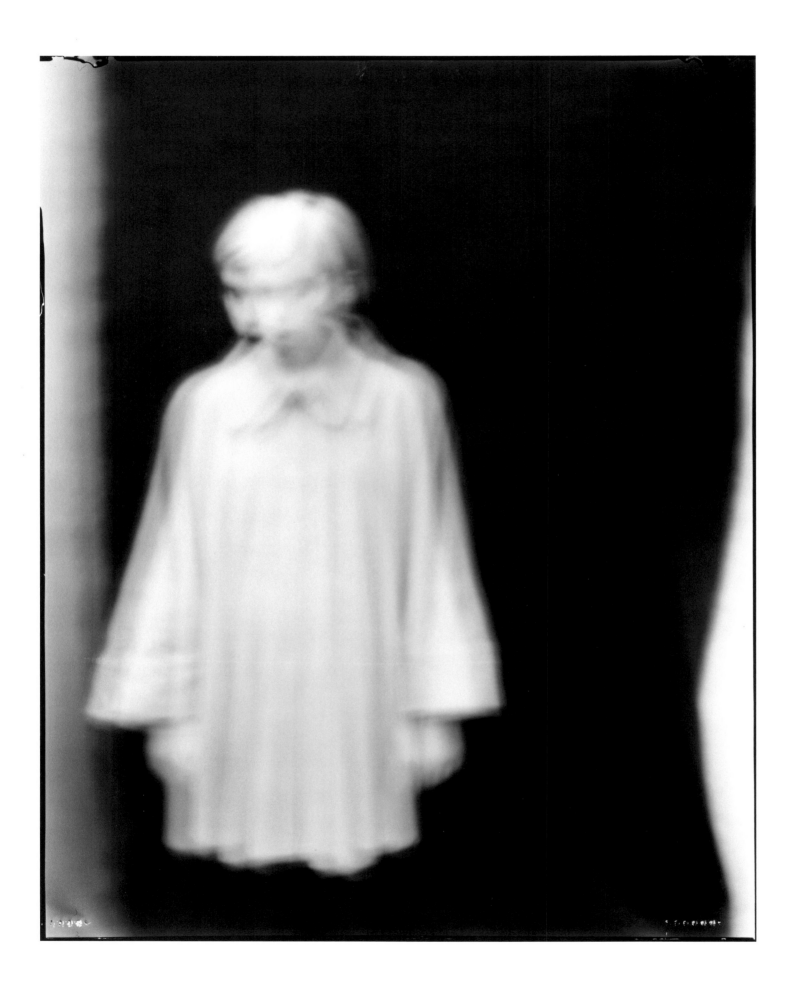

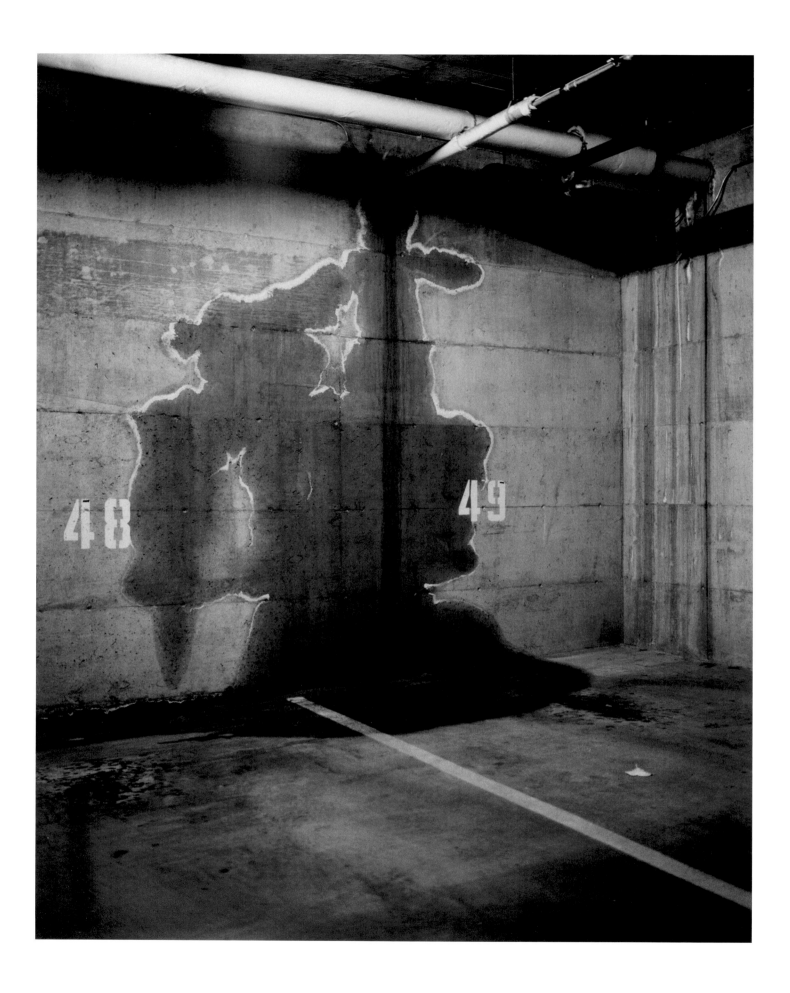

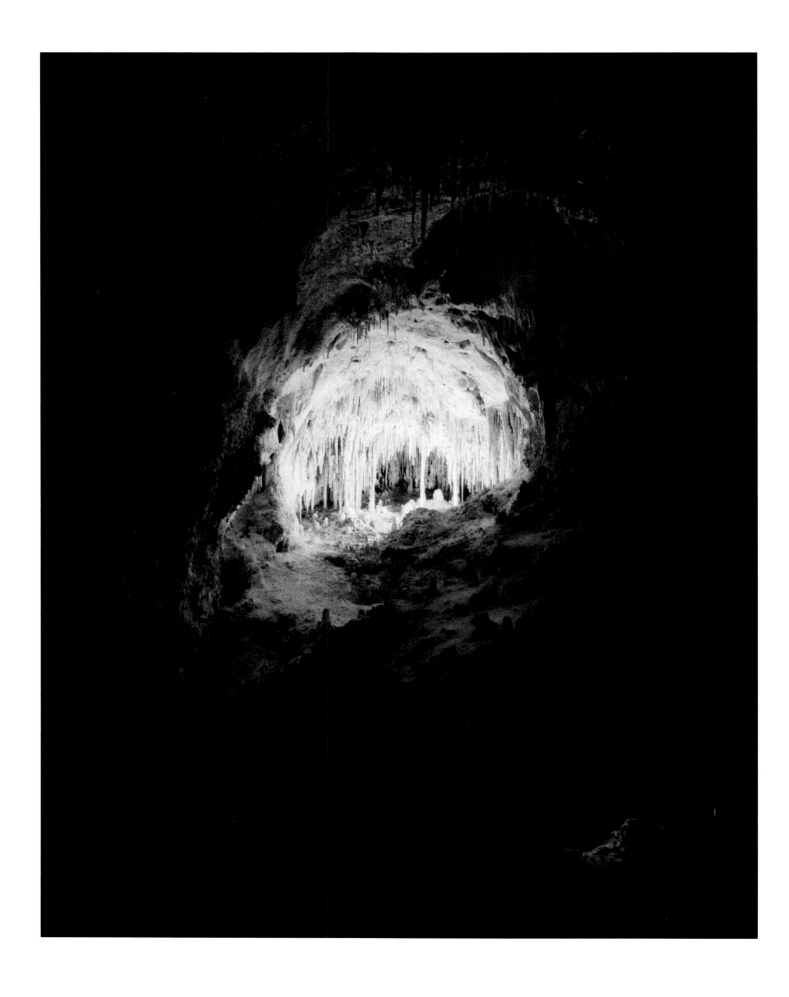

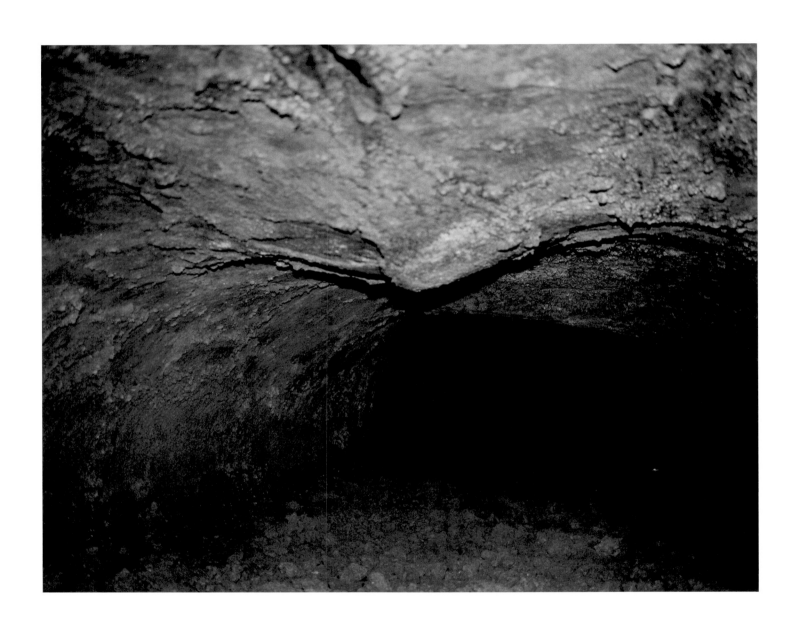

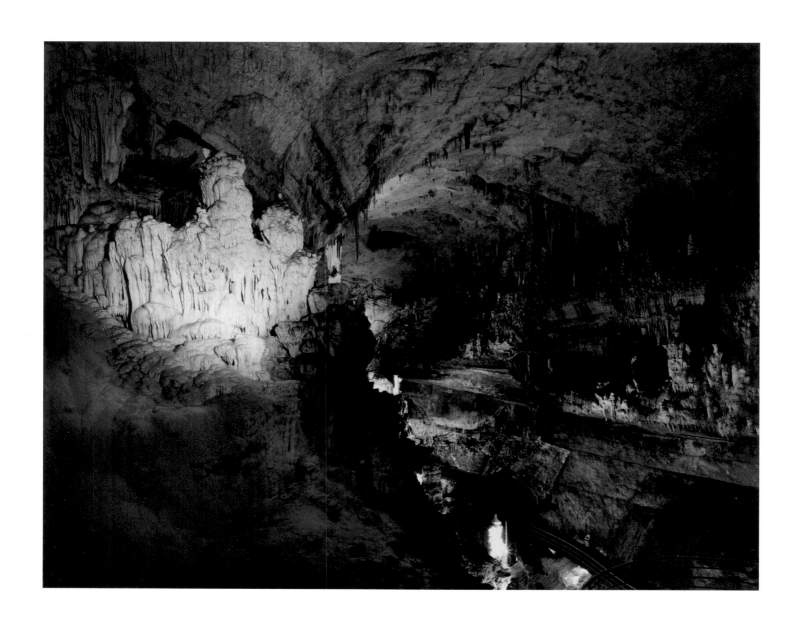

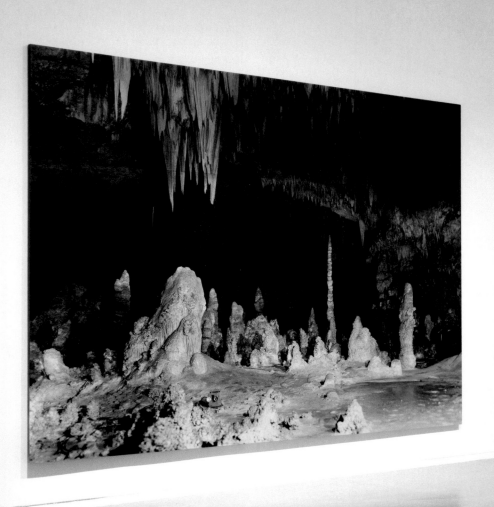

Dark Matter Atlas exhibition (I)
Installation view, Vancouver Art Gallery, 2016

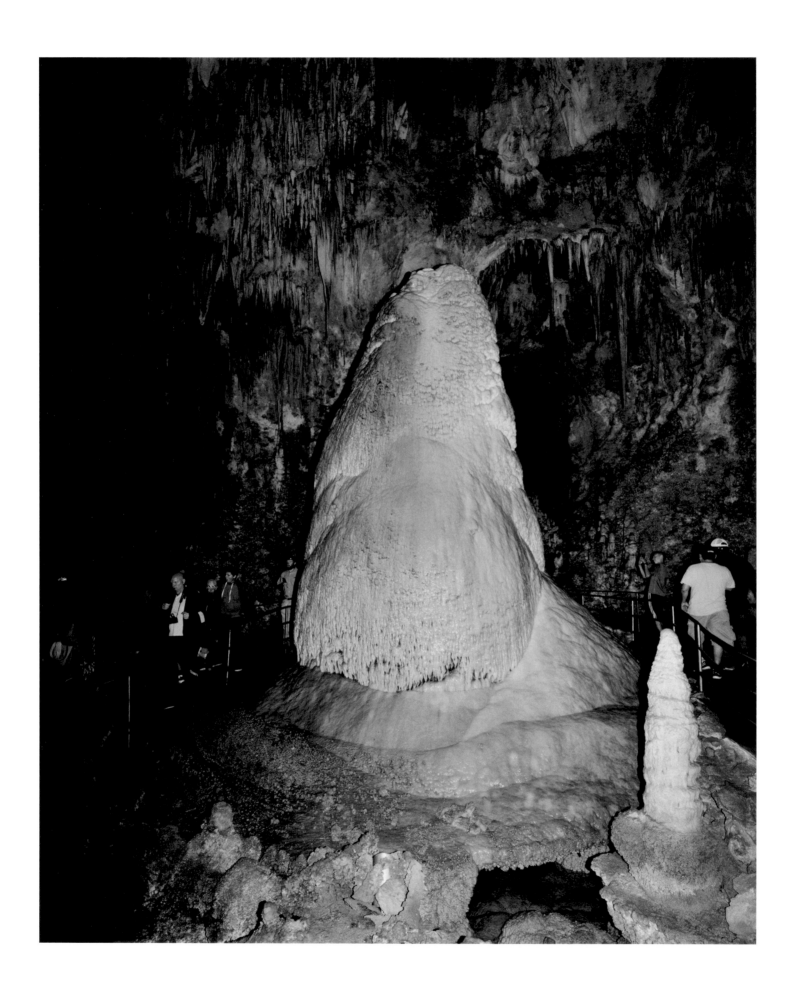

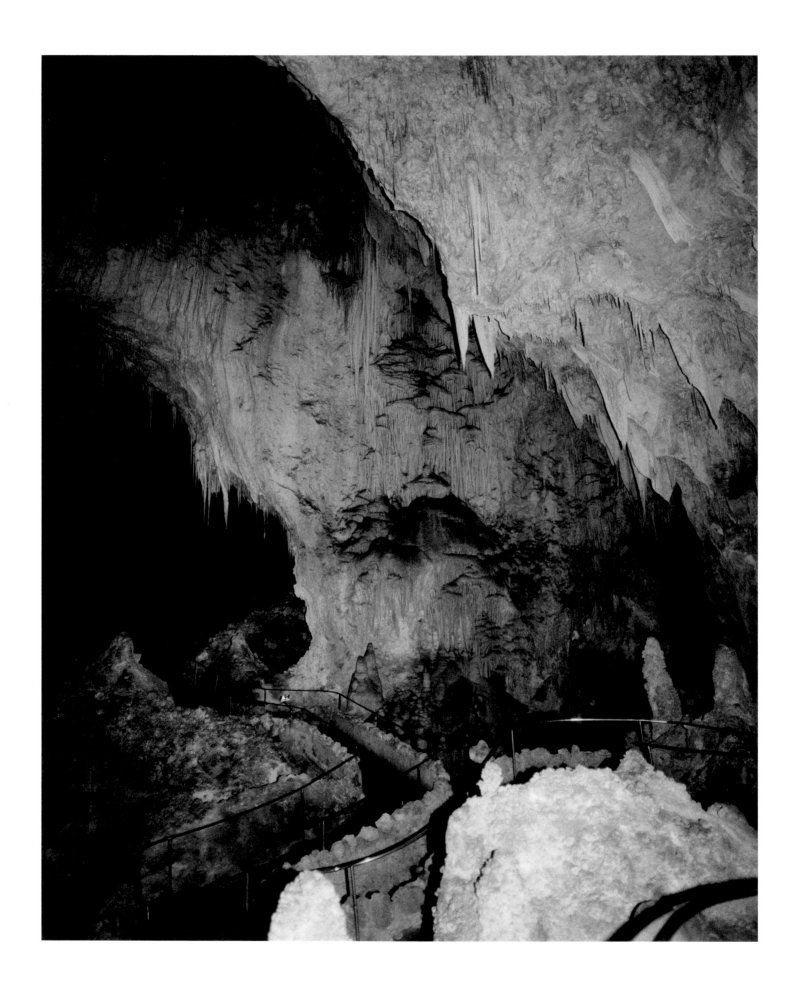

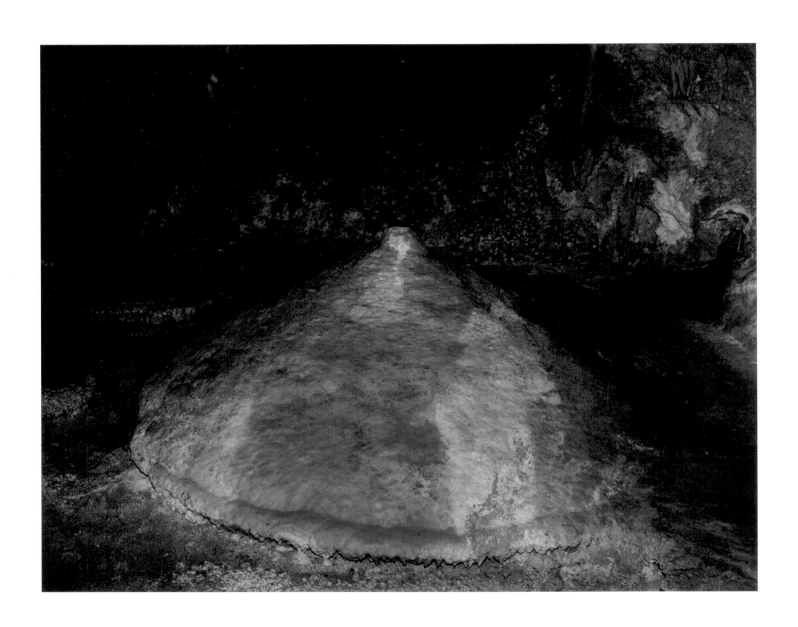

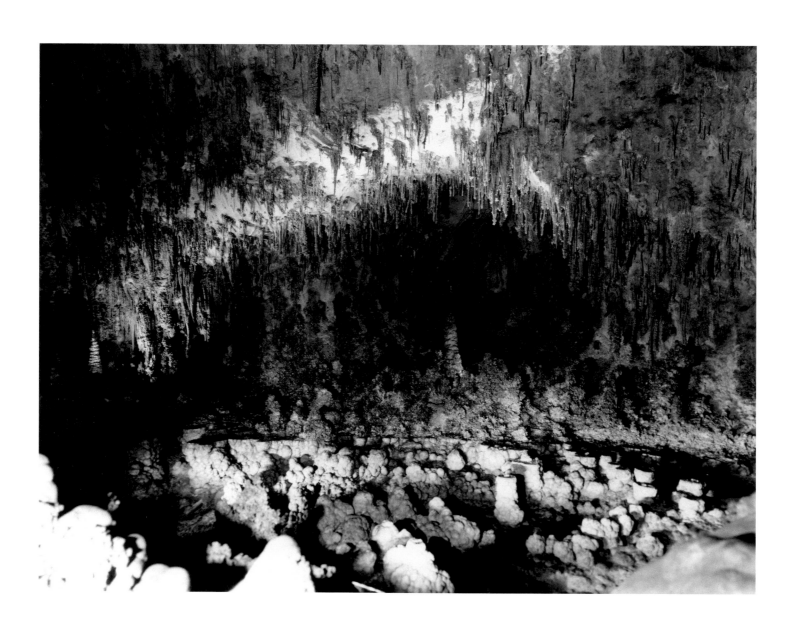

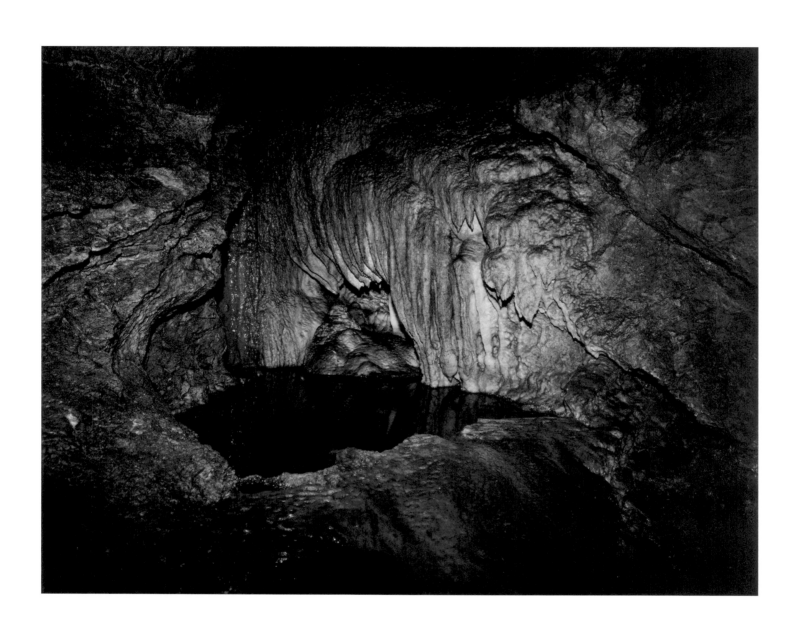

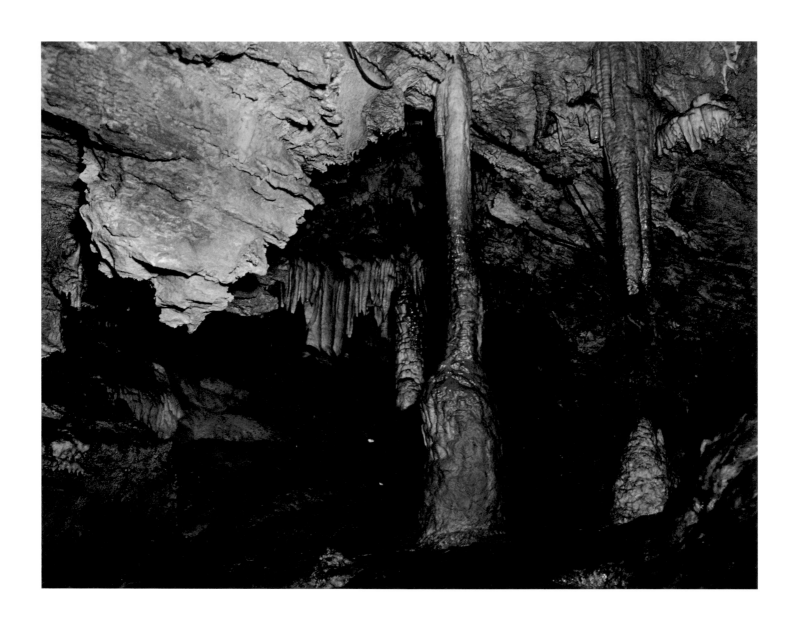

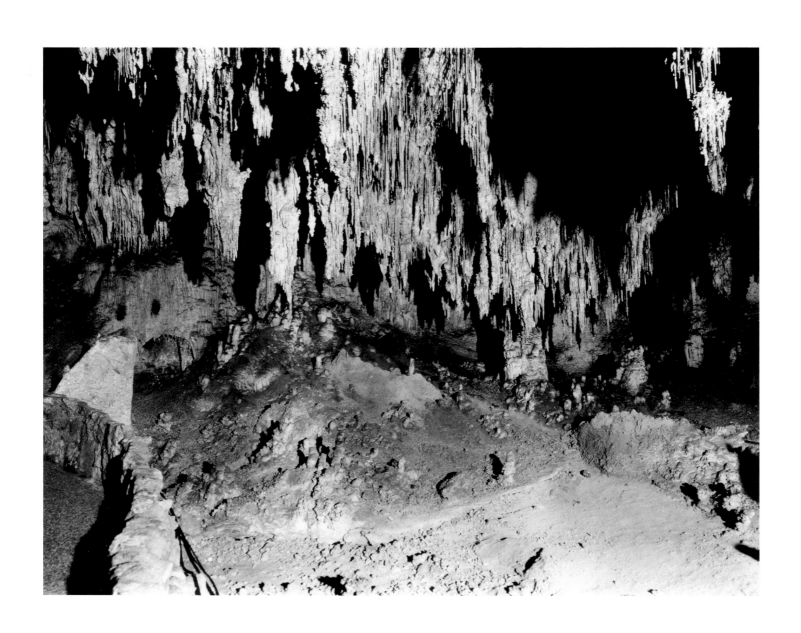

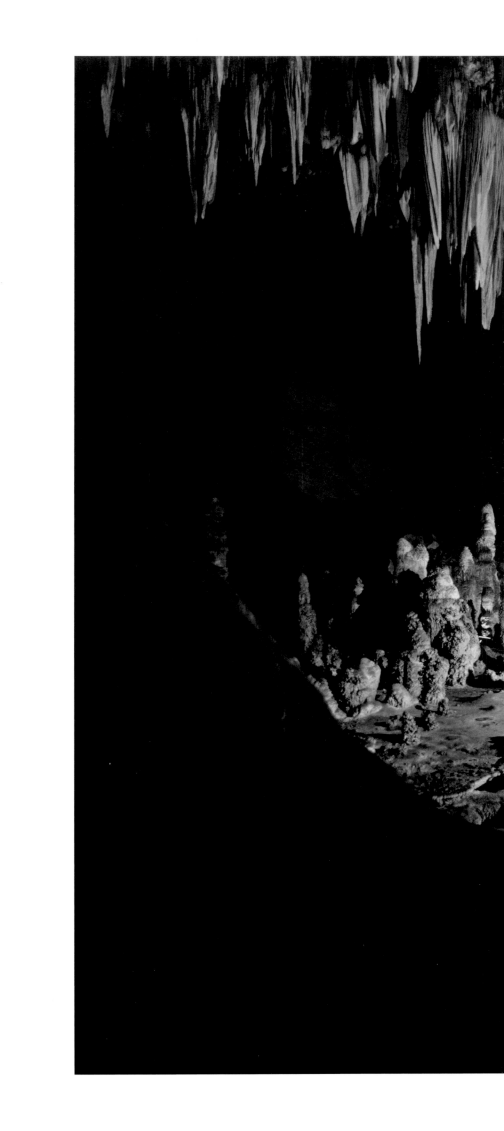

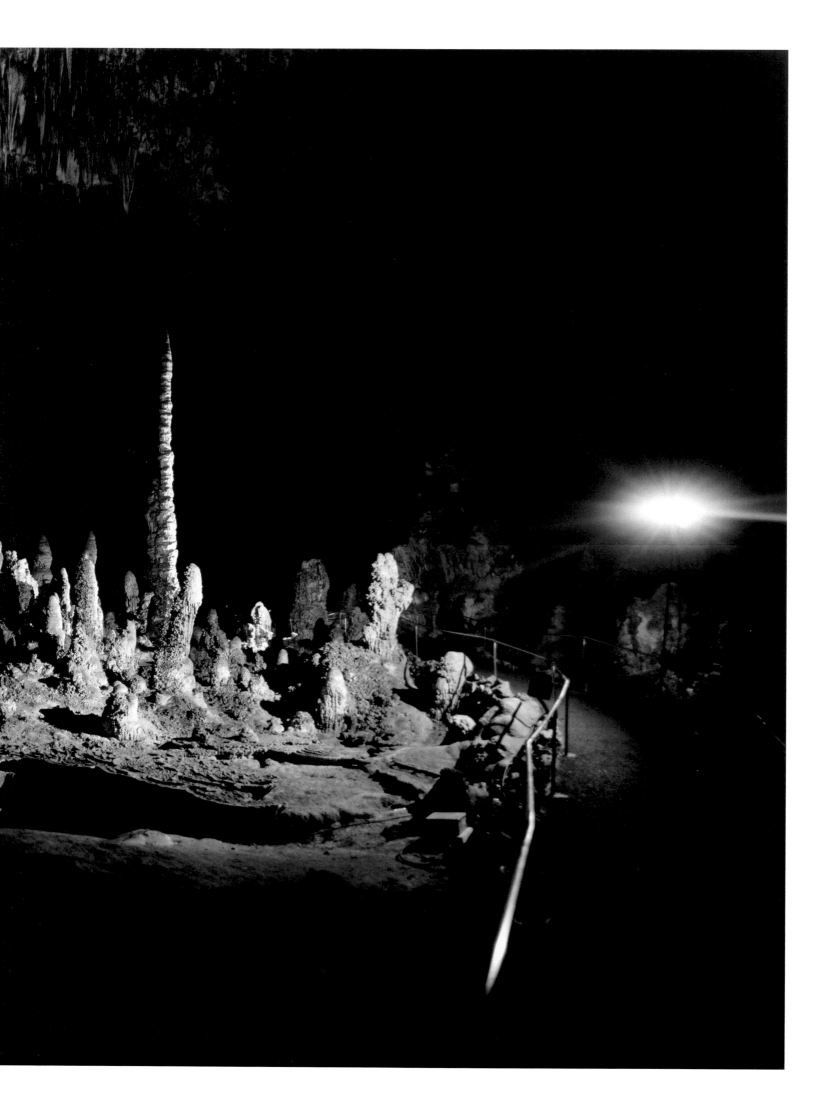

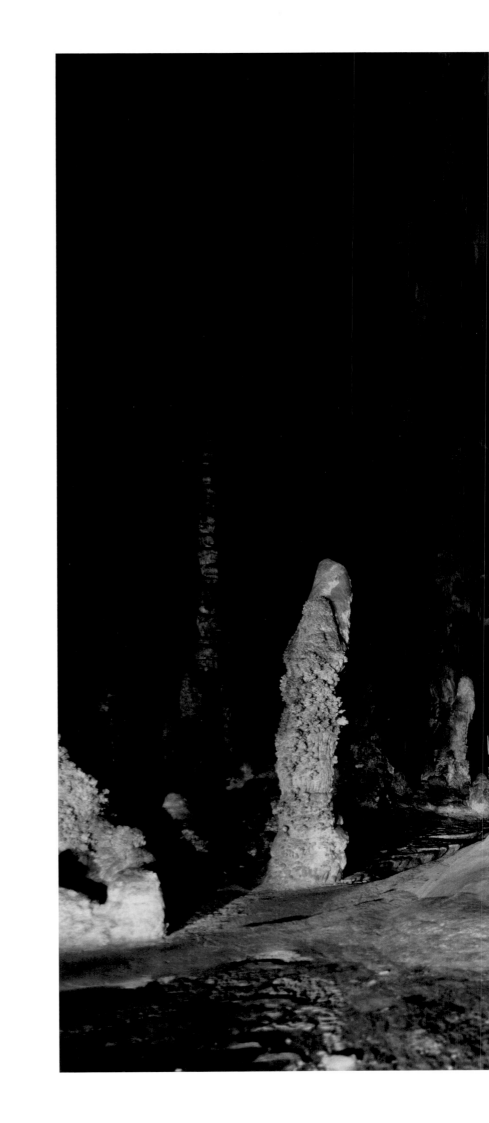

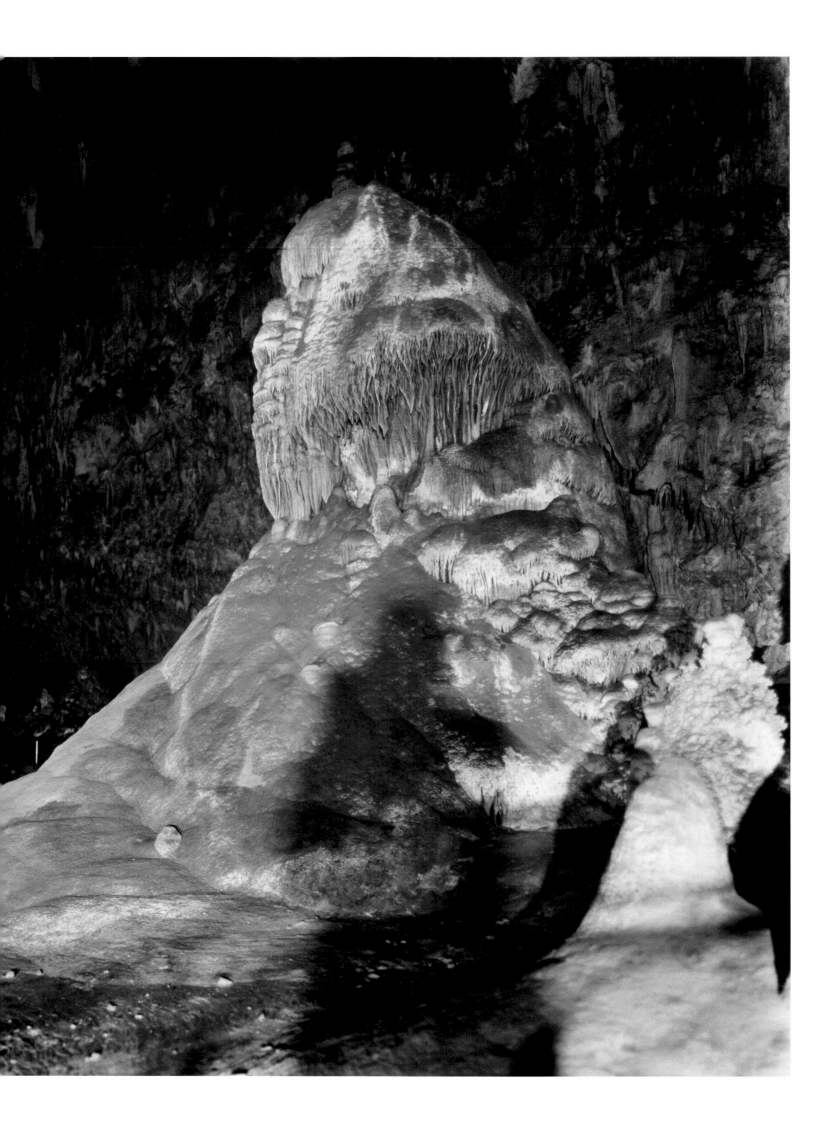

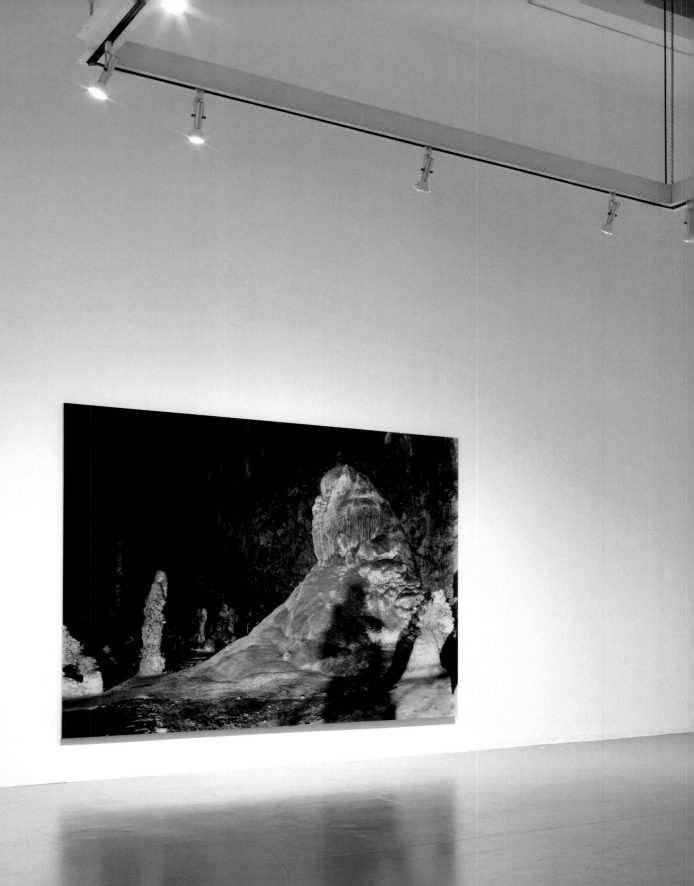

Dark Matter Atlas exhibition (II)
Installation view, Vancouver Art Gallery, 2016

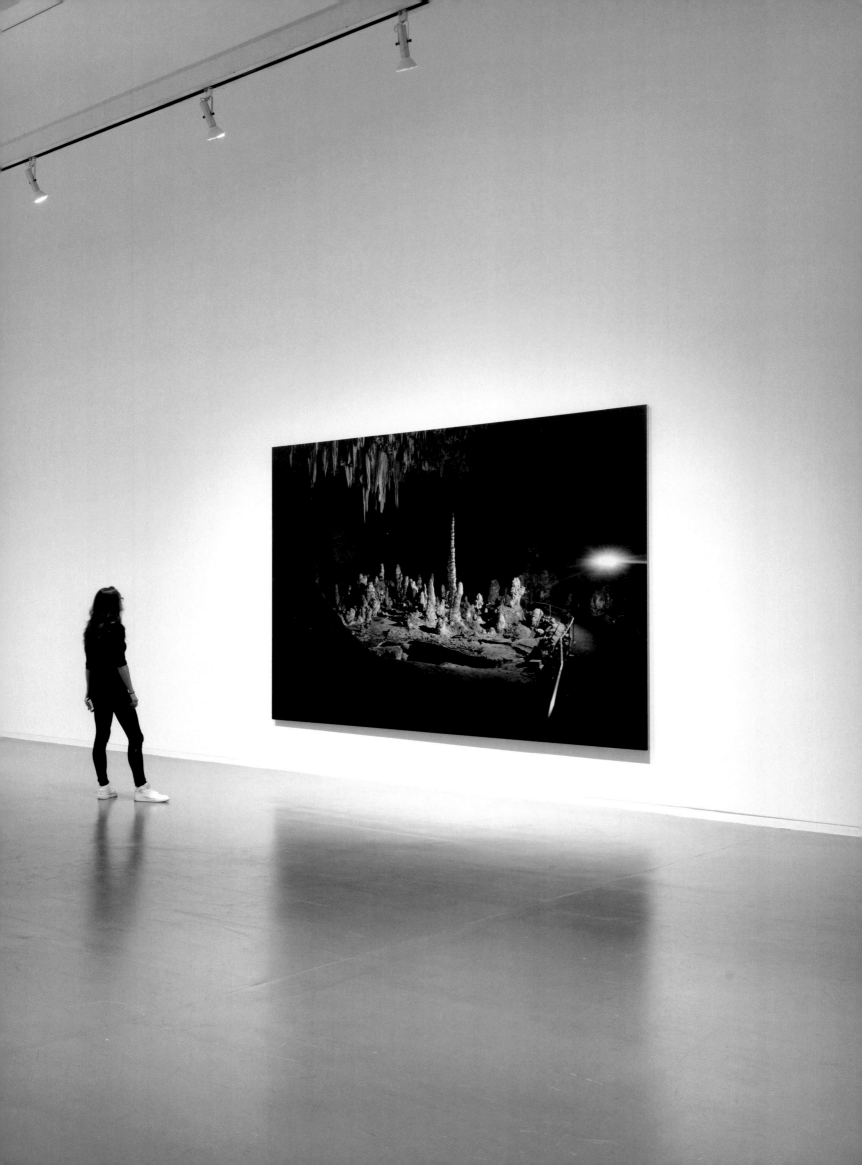

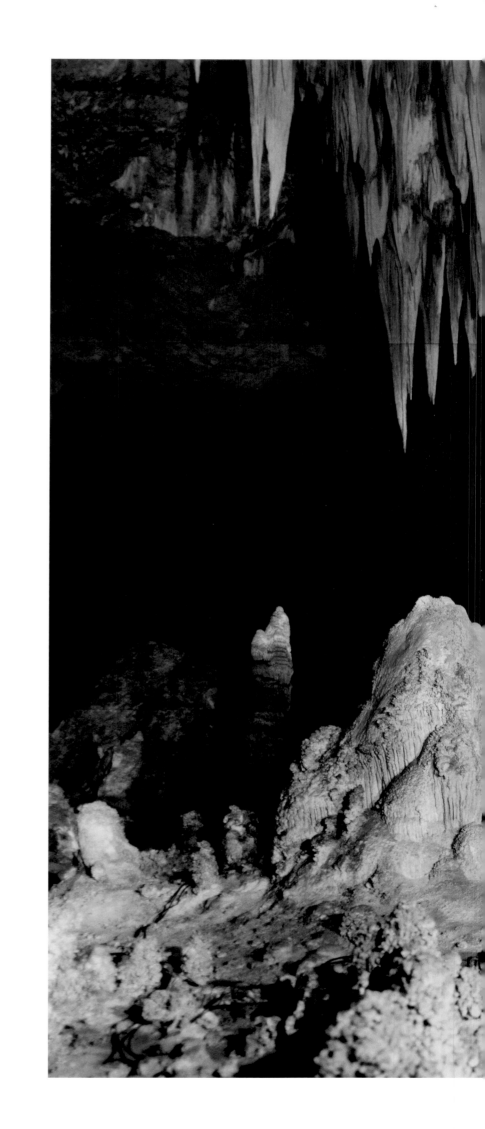

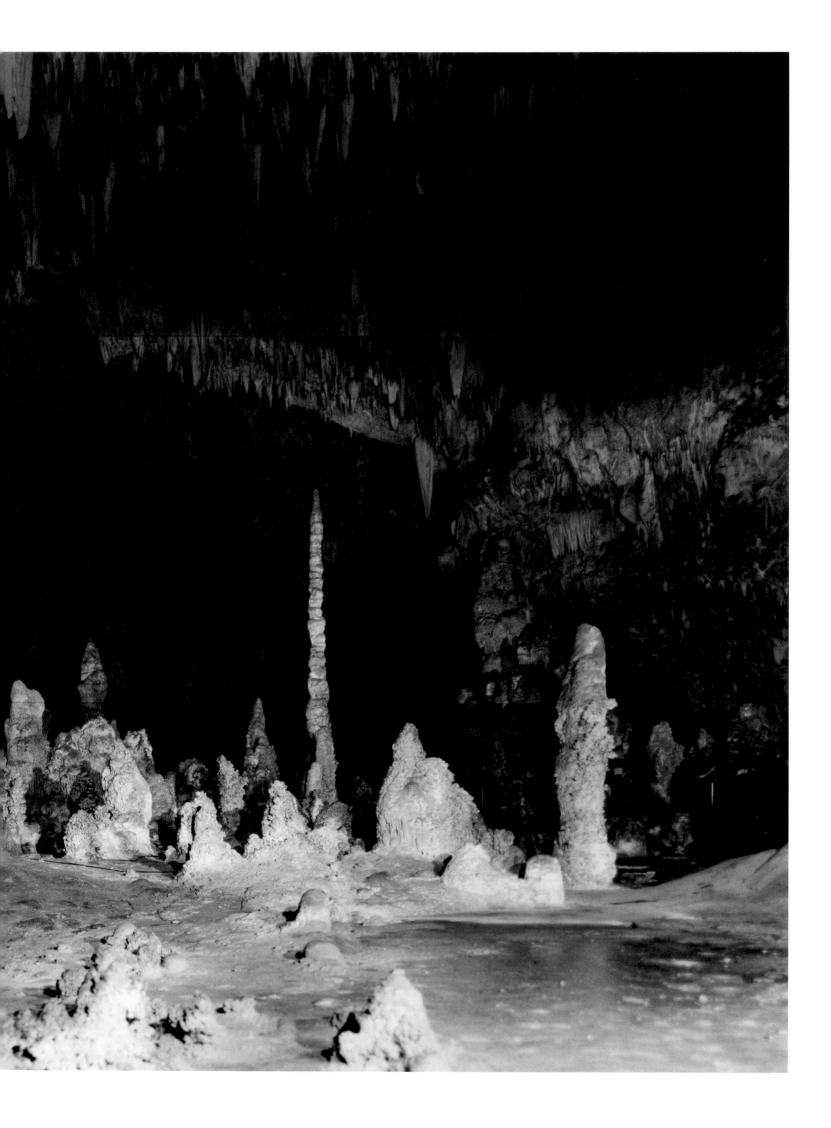

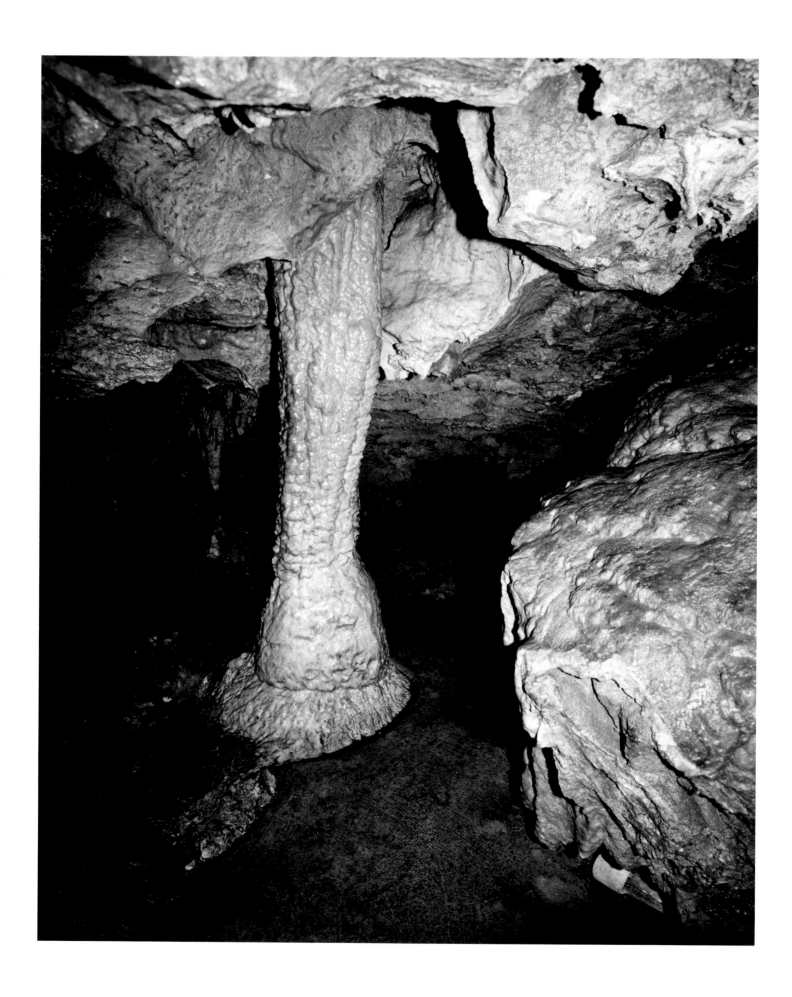

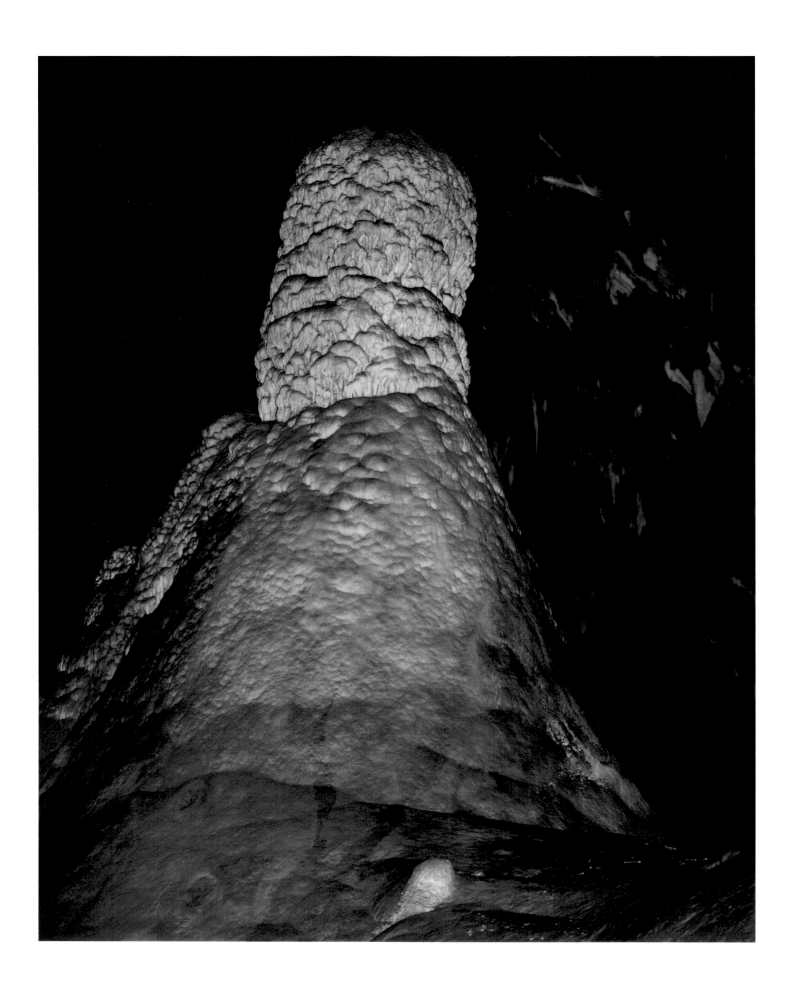

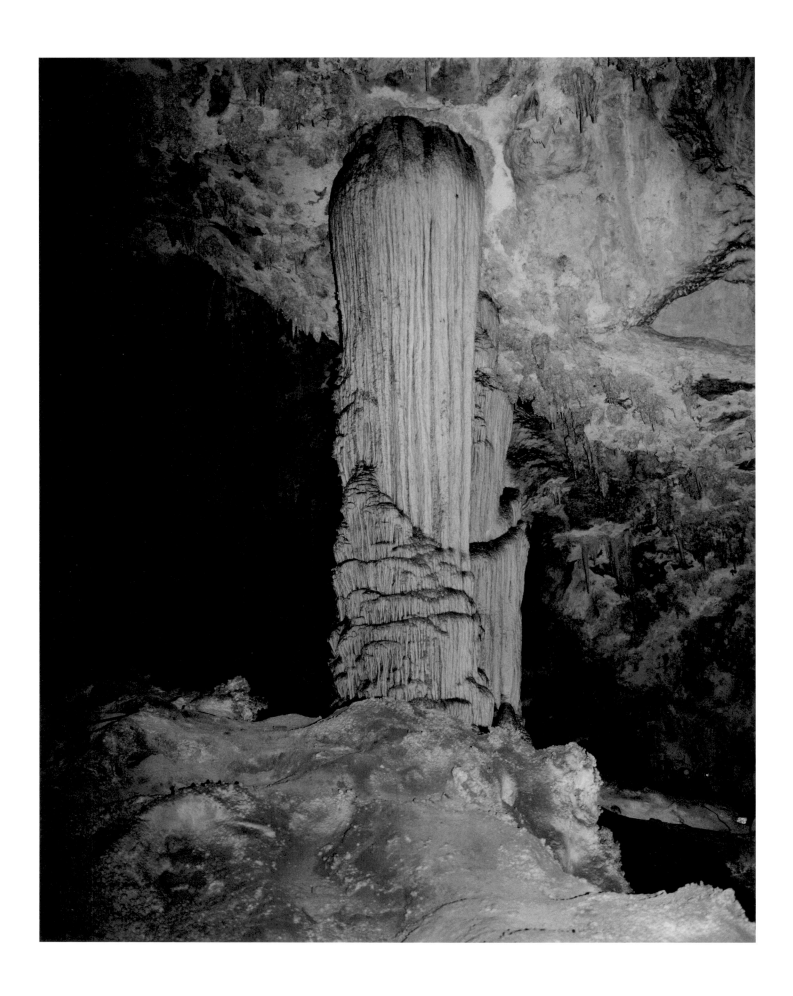

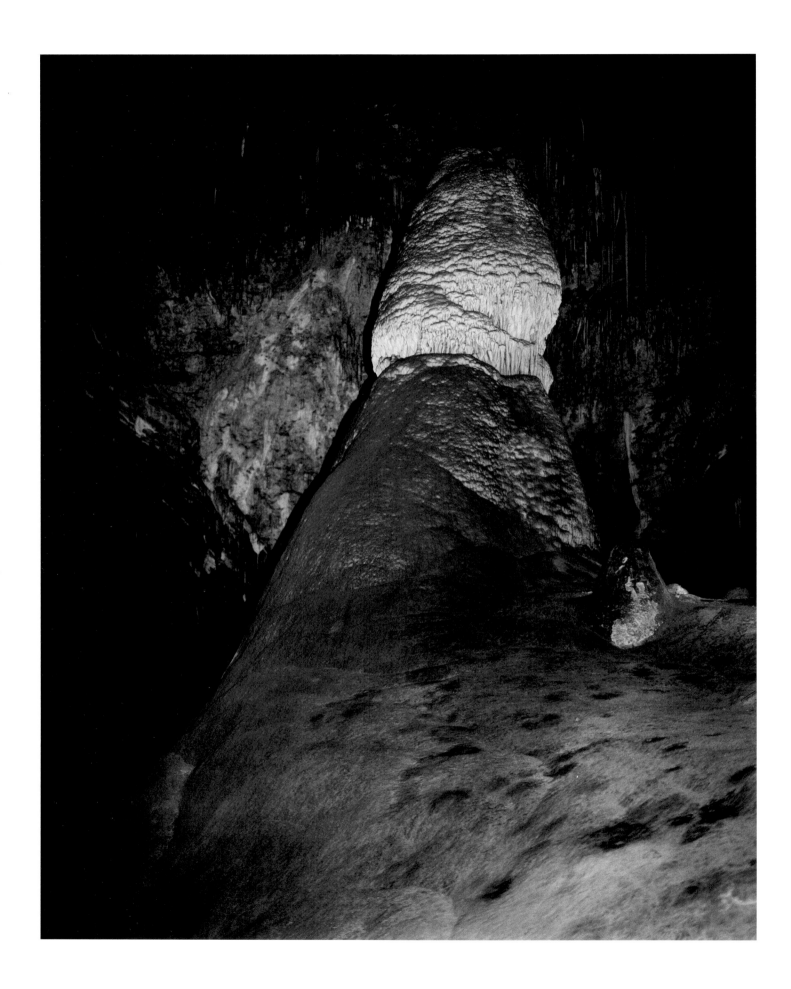

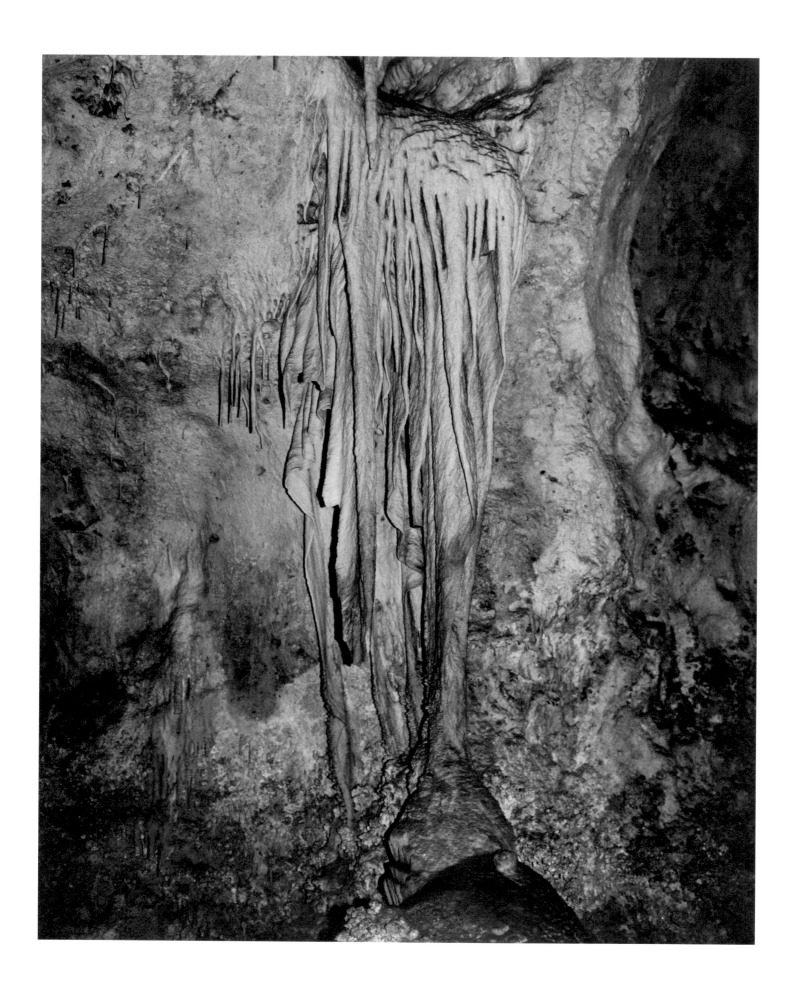

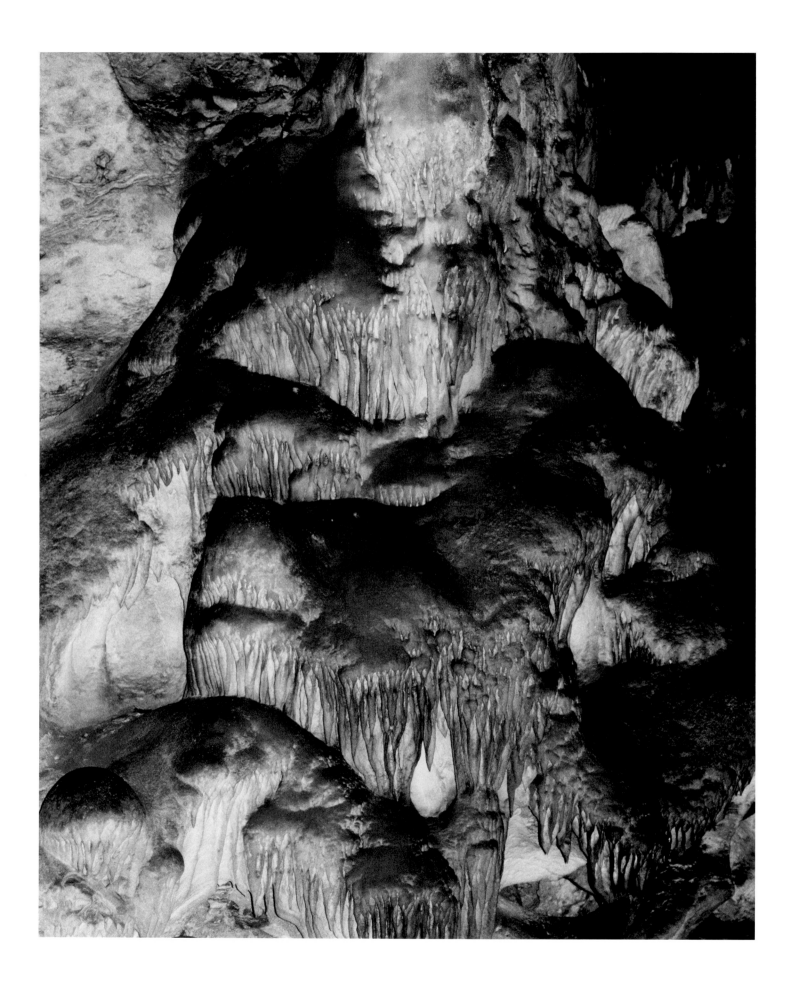

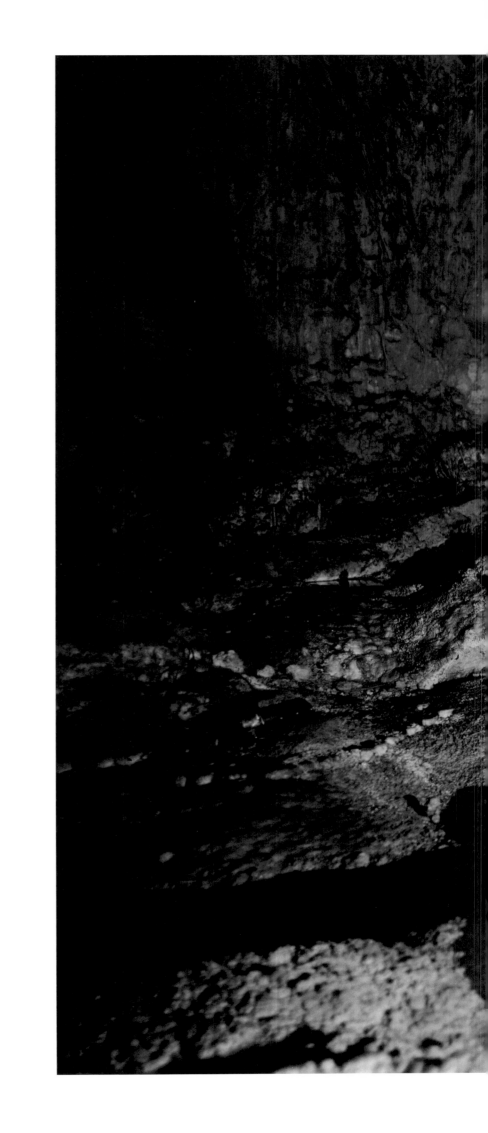

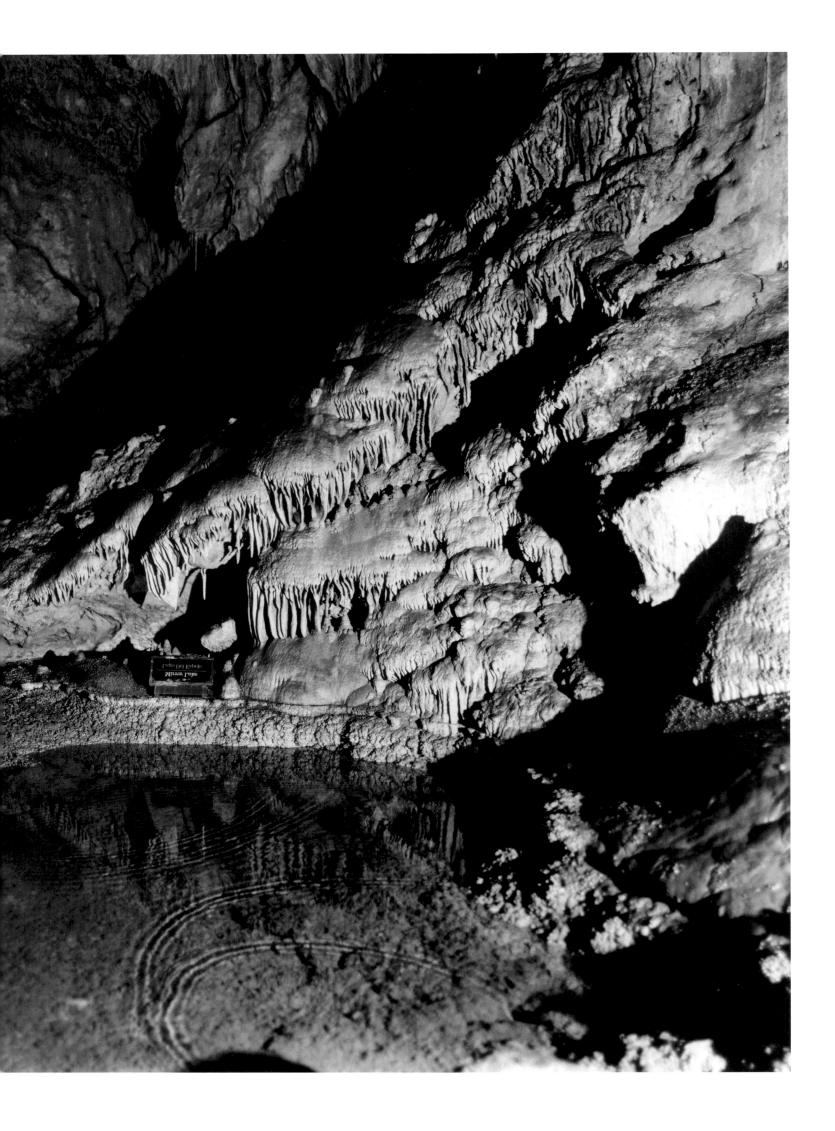

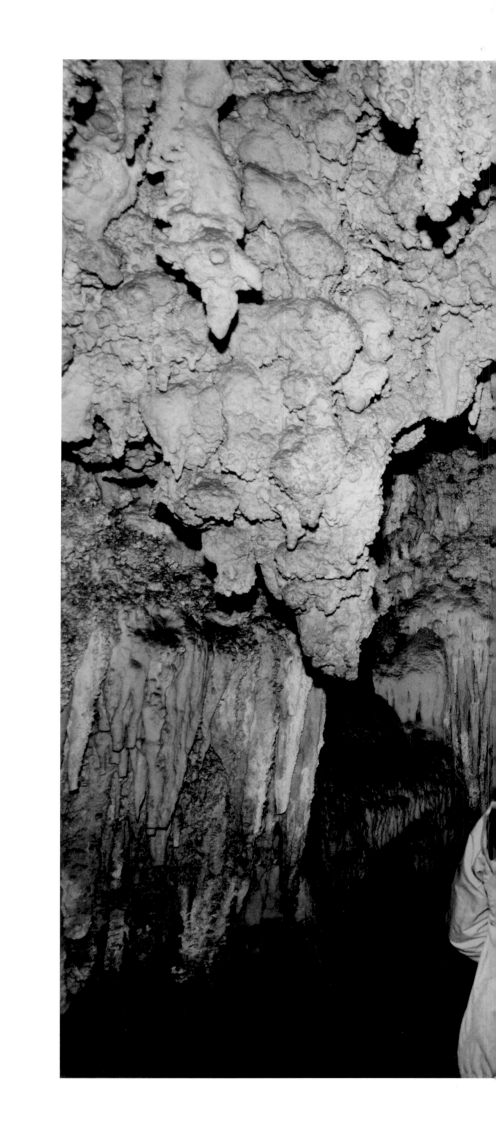

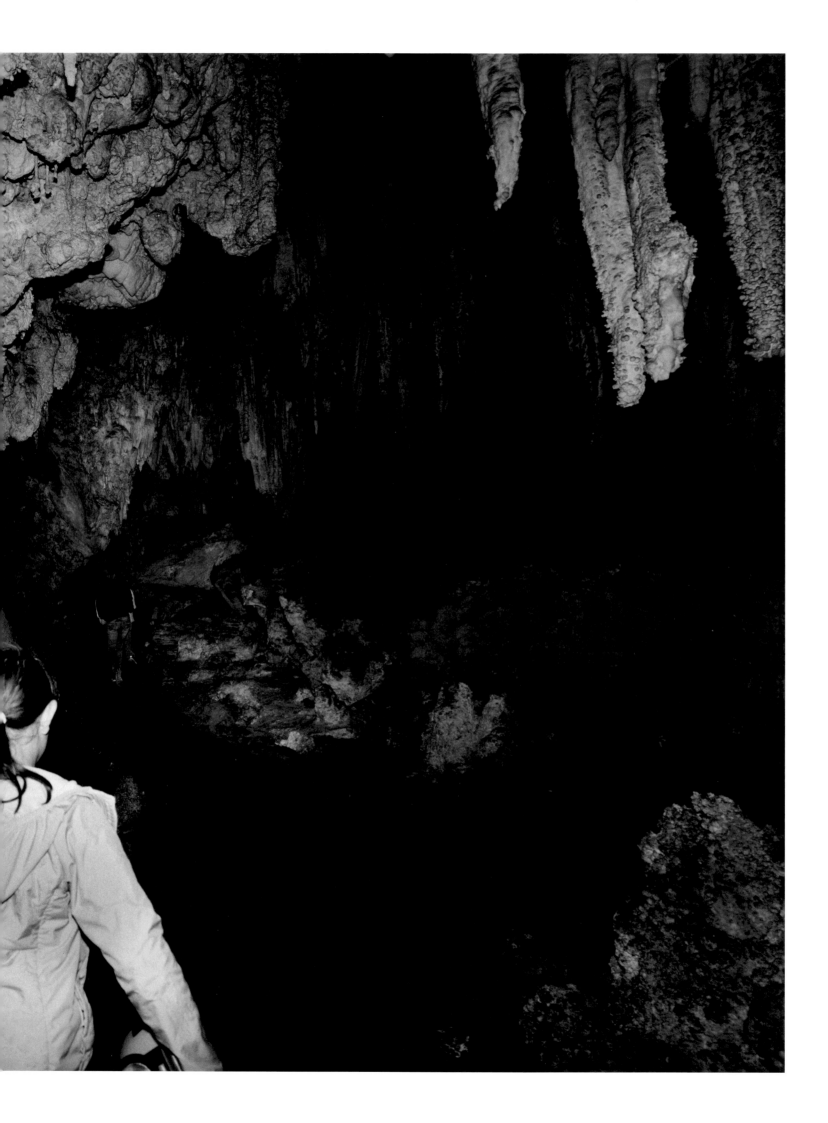

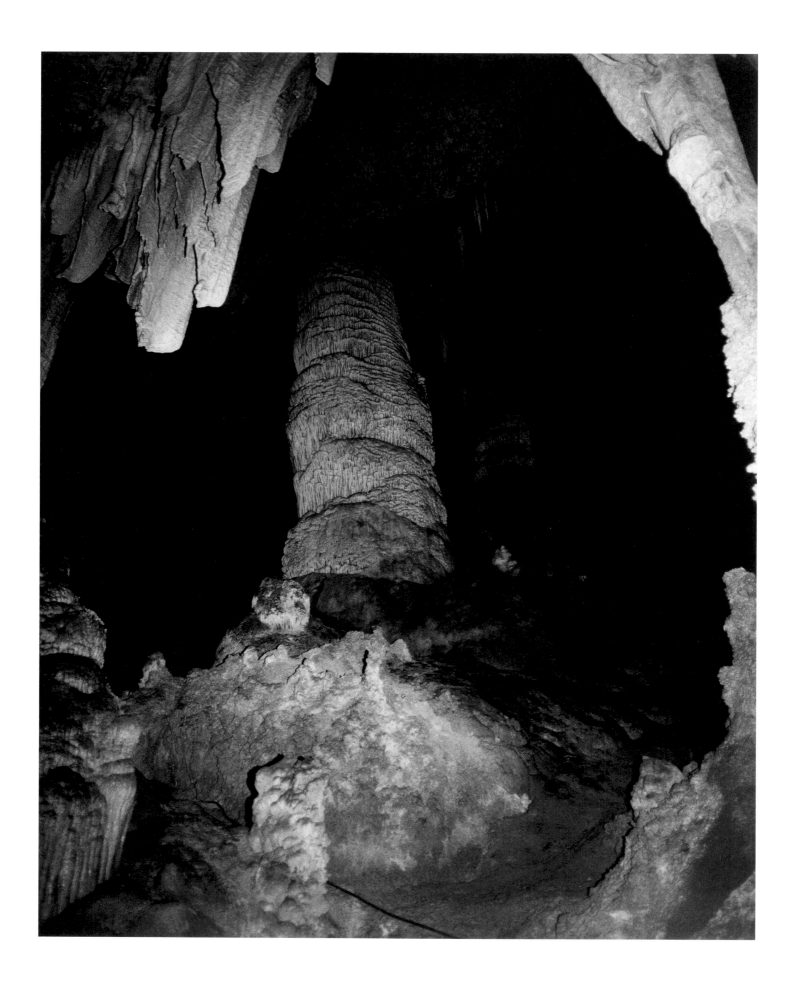

Fielding ran up to see one cave. He wasn't impressed.
E.M. Forster, *A Passage to India* (1924)

Underworlds

The human urge to make pictures might have originated underground, on rough stone walls, in torch-lit caves. Palaeolithic artists might have seen the leg of an ibex or the head of a bird in a crack on the wall of a cave, little images that would prompt larger paintings.[1] A pervasive legend, cited by Pliny, Alberti and others, is that painting was invented when the first artist had the wits and tools to trace a shadow on a wall. Leonardo da Vinci advised artists "to stop sometimes and look into the stains on walls, or the ashes of a fire, or clouds, or mud, or like things, in which, if you consider them well, you will find really marvelous ideas."[2] Chinese scholars' rocks, with their crags, curves and portals, have been mute generators of ideas for poets and artists for at least a thousand years. The impulse to create begins with the act of looking. Stones also taught us about the earth we stand on and our place in the universe: Charles Lyell had a good look at layers and patterns in rocks and declared the existence of "geological time," helping to replace the authority of god's word with the wisdom of the deductive eye.

When Stephen Waddell paused to look at a dark, shadowy form on the wall of an underground parking garage, and made the picture *Stain* (2012) at the site, he drew upon an ancient tradition of deriving ideas from "chance images."[3] *Stain* redirected Waddell's imagination, and the underground car park became the antechamber to *Dark Matter Atlas*, the first substantial body of work in black and white for an artist best known for his distinctive use of colour photography.[4] While ultimately leading to a series of photographs of caverns and grottoes in Sicily and the American Southwest—another first for the artist: working in a series—he interpolated two seemingly unrelated photographs into the group: *Portrait Bust* and *Understudy* (both 2015). These pictures offer a kind of connective tissue to the history of figurative art: *Understudy* depicts the busted legs of the world's first hard man, Hercules (whose first labour was to kill a cave-dwelling lion), and *Portrait Bust* a medieval aristocrat. For *Dark Matter Atlas*, these fragments of myth and history act as reminders for the viewer: look, over the past 2000 years, this is what we usually expect from representational, or mimetic, art. The bust and the legs are not random stains or evocative natural forms, but cultural artifacts that served a particular narrative or purpose. Photography often struggles to escape from this narrative or descriptive convention of pictorial art. The intention of *Dark Matter Atlas* is, in part, to alter our understanding of what a photograph can do. Waddell wants to put myth and history aside—all those external stories and all that emphasis on subject matter—and climb inside the clammier world of the viewer's mind.

Waddell shot *Portrait Bust* in Palermo, Sicily, and there are hints of *Dark Matter Atlas* in other photographs from his trip to the island: the serpentine form in *Orto Botanico 1* (2014), or *Restorer* (2014), which depicts a woman repainting damaged marble, suggesting that we value the look of natural forms so greatly that we will painstakingly restore them with art. But I would trace the idea of the cave, of the interior life, even further back in Waddell's oeuvre. The *rückenfigur*—a figure viewed from the back—has turned up everywhere in Waddell's work since he started taking pictures: in *Le Pêcheur*, (2000), *Man Sketching* (2004) and *Arbutus Corridor* (2009) to name just a few. The *rückenfigur* implies an empathetic viewpoint and a psychological interior: we enter the world of another person looking at a landscape, absorbed in banal thought or aesthetic reverie. Even when Waddell's work resembles a form of street photography, served straight up, his pictures propose a psychological space as much as a depiction

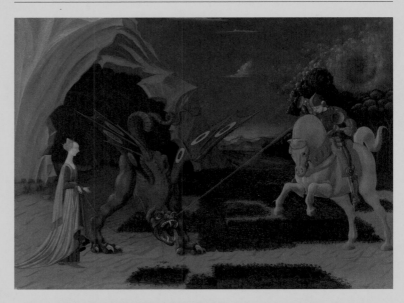

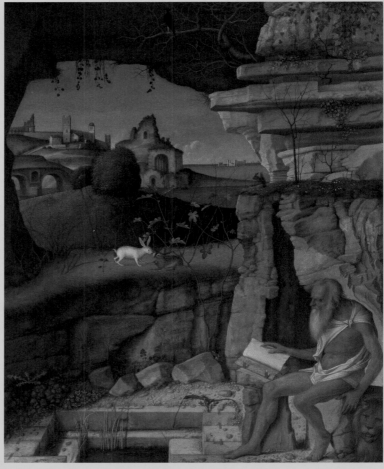

Paolo Uccello, *St. George and the Dragon* (c. 1470)
Giovanni Bellini, *Saint Jerome Reading* (1505)

of the phenomenal world. They invite the viewer to look inside—
to examine what it might mean to see from within someone else's
consciousness. *Stain* suggested to the artist another layer of
interiority: the ghost on the wall invited him to go somewhere darker,
more irrational; to climb inside the unconscious.

Until now, I've been avoiding entering the caves, as if a little worried
about what I might find inside. Can you blame me? They demand a
lot from the viewer. Look at the picture titled simply *Cave* (2016). In
the foreground, some blurry forms in light grey, a path that snakes
from left to right and back, all beneath two rock formations that
resemble giant ghouls' mouths in eternal gape, their shark-like teeth
ready to slice through a soft body. The metal bars are reassuring,
the trail smooth, well-trodden, and yet the attraction here is the
ghoulishness, the surreal unfamiliarity of the scene. The path through
the cave acts like the numbers in *Stain*—they remind the viewer
that, however enigmatic in appearance, this is just an everyday
cave where thousands of visitors walk and make snapshots of the
infinite patterns and formations on the cave's walls. We feel this
dual register while looking: a twinge of horror, and the reassurance
of knowledge that cuts through and clarifies formlessness. What we
really want, I'd wager, is a little more of the engulfing void, and the
unpleasant company of a few more phantoms.

The mood of the photographs ranges from the repellent, almost
terrifying, in pictures such as *La Grotta dei Lamponi (After Henry
Darger)* (2015), *Entrance* (2016), or *Veil* (2016), to the light-hearted
and playful, in pictures such as *Onlookers and Wet Stalagmite No.2*
(2016) or *Jeita* (2015). *La Grotta dei Lamponi (After Henry Darger)*
conjures a feeling of being buried alive, or the engulfing mouth of a
whale. Where does *Entrance* lead—outside, or the underworld? This
strange aperture—the structure of a camera is, after all, a lot like a
cave—asks us to imagine what we can't see, or to question the
very limits and structure of our perceptions. You might look at *Veil*
as an image of the endless flow of a mineral stream or the ghoulish
ooze of a monster's head. *Onlookers and Wet Stalagmite No.2* has
a fairground atmosphere, with the tourists in their baseball caps
and cameras, rounding that enormous pot-belled blob of stone.
Jeita, a relatively small picture, could likewise suggest the facade
of an amusement ride: a hydra-like beast looms up on the left side,
all billow and droop, as if guarding the entrance to the cave and
greeting the visitors with a goofy boo! Look again and you might
be reminded of the bewildering sense of entrapment in a Piranesi
prison: paths and stairways lead to an infinite regress of more paths,
metal bars and impenetrable walls.

Caves and craggy landscapes have long entranced artists beyond
any literal or descriptive purpose. They often suggest an inner realm
distinct from the narratives of the masculine hero, or some deep,
primordial force that escapes our understanding. Look at the cave in
Paolo Uccello's *St. George and the Dragon* (c. 1470):[5] it is an open-
ended symbol of everything that is opposite of the knight: curvy,
decorative, dark—the unfathomable vulva to St. George's slender
lance. The exterior of Uccello's cave is not dissimilar to the one in
Bellini's *Saint Jerome Reading* (1505),[6] and the implication in this
painting is that the cave is an image of the life of contemplation, a
retreat from action. Why would Bellini take such care with the stone
formations above the saint? They are "chance images" offered up as
aids to reflection for the contemplative saint—and for the viewer of
the picture, who is invited to adopt the saint's attitude while looking
at the landscape. A classical Chinese landscape painting such as
Lu Zhi's *The Jade Field* (1549)[7] is not dissimilar in its emphasis on
the texture of the overall surroundings: two monks approach the

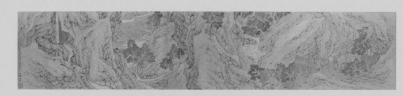

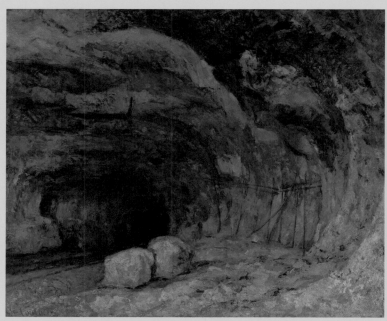

Lu Zhi, *The Jade Field* (1549)
Gustave Courbet, *Grotto of Sarrazine near Nans-sous-Sainte-Anne* (c. 1864)

mouth of a cave, the landscape around them a lush pattern of greens and blues that overwhelms the figures. Think of Courbet hundreds of years later, making pilgrimages to river sources, caves and mossy cliffs, and painting them so suggestively that they herald the corporeal lushness of gestural abstraction. It's no coincidence that Waddell's *La Grotta dei Lamponi (After Henry Darger)* bears a composition and mood similar to Courbet's *Grotto of Sarrazine near Nans-sous-Sainte-Anne* (c. 1864).[8]

Step inside a cave and, before you see any bat or eyeless fish, you'll encounter the very structure of your senses and imagination, all raw, dark and twitching. Adela Quested, the English schoolmistress of E.M Forster's *Passage to India*, heads to the Marabar caves to look for "the real India" but finds instead her own libido or unconscious. She flees in horror, accuses a local doctor of rape, and provokes a crisis in the community. Her friend, the older Mrs. Moore, had already visited the caves and couldn't face another trip within. She found there only an infinite echo, the big "ou-boum" of a formless, amoral world, emerging from the cave to conclude that "everything exists, nothing has value." Compare these characters to Fielding, the local governor who "eats everything and talks to everyone," and who "was not impressed" with the cave simply because he has no imagination, or no use for the irrational. ("A mystery is a muddle," he says at one point in the novel.) Caves are tuning forks for psychological states, or aesthetic needs. A cave is a dark gallery, a flagrantly aesthetic realm, an inner world where the imagination plays. One must be prepared to confront sex and death in a cave, even in New Mexico.

If caves are infinite inkblots to our imagination, *Dark Matter Atlas* is not a series of photographs about caves or landscapes but about you, the onlooker, and about your faculties of perception. Maybe you're a Fielding and you'll turn away, indifferent, seeing only numbers beside the stain on the wall or nature at its most useless, or maybe you're Courbet, and you revel in the moist fissures and chthonic fumes. The title *Dark Matter Atlas* expresses a paradox, implying an impossible object: a map of the unknowable. *Stain* presents to the viewer two orders of experience. We see both ambiguity—the suggestive blob—and a utilitarian structure, the coexisting realms of organization and of imagination. The numbers and lines restrain any outrageous flights of fancy, reminding the viewer that although there might be a monster on the wall, it's just an everyday occurrence in an urban cave. And yet who would fail to respond to the voluptuous shadows? Why are people so drawn to caves? Zeus was born in one on Crete, lovelorn Polyphemus made his home in another on Sicily. Plato set his allegory of epistemology and dissembling in a cave. Caves are associated with the very origin of knowledge and act as an emblem of our inner life, and yet we also fear them as the murky lairs of monsters.

Two portraits express this double nature. *Ranger Laura* (2016) faces the viewer with a relaxed smile, her hair controlled in tight braids beneath her broad-rimmed hat. The photograph has the air of a conventional portrait, an image you might find in a leaflet for the caves. Here we have the optimistic psycho-pomp of the empirical world, grinning amid enigma. Ask me anything, she seems to say: I am the offspring of Charles Lyell and I will talk to you about speleothems and time, about minerals and erosion. She will interpret all this hardened chaos, offer an explanation that disabuses our imagination of all its monsters. These strange formations are not phalluses and breasts, ghouls or giants, but accumulations of minerals; they are mere natural phenomena. We have the means to measure their age and analyze their composition. In fact, we know

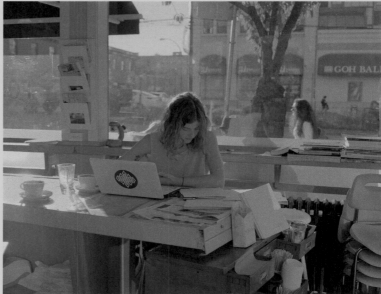

Robert Bresson, *Mouchette* (1967, film still)
Stephen Waddell, *Jelena* (2014)

everything about them. What's the big deal? The figure depicted in *Mouchette, Queen's Chamber* (2015) is less sure. Here we see a vulnerable Eurydice about to enter the underworld, a young girl striding into blackness, rough stone teeth a threat to her flesh. Her ponytail falls over her back, the flow of her hair a synecdoche of the flow of stone in the cave. We see her from the back—a *rückenfigur* that Waddell so often deploys—and as viewers we are invited to imagine her emotional state, or to place ourselves in her position. The title refers to Robert Bresson's *Mouchette* (1967),[9] the story of a girl whose existence consists of a great deal of suffering and humiliation before her early death. The stone that engulfs her is the opposite of a human being: cold, hard, brittle, immortal (or almost), devoid of desires and yet expressive of ours. Waddell's *Mouchette* embodies our ephemeral flesh, reminding us that all of our knowledge will never overcome the pain of knowing that we are mortal.

Before we go deeper into the caves, compare *Laura Ranger* and *Mouchette* to *Jelena* (2014), a picture more typical of Waddell's oeuvre yet made after *Stain*. *Jelena* is an everyday scene heightened to a vision by the unifying balance of silvery greys. With the bright window light and the depiction of a woman at a table absorbed in an everyday task, it's hard not to think of a painting by Pierre Bonnard. Yet distinct from a Bonnard portrait—where the materiality of the painting's surface and swathes of saturated colour offer non-signifying sensation to the viewer—*Jelena* overlaps with our everyday experience of sight, and its force lies partly in that immediate legibility. (I overplay it a bit here: *Jelena* is a photograph worth looking at because of the patches of palpable light.) If legibility is the gift of photography, it is also its limitation. In a realist tradition a photograph often conveys, no matter what the subject matter or formal qualities, a feeling of eyesight—and thus the limits of subjective perception. We see the world as we experience it, trapped in the here and now: a moment, snapped from the flow of time, frozen and represented. The camera is a one-eyed monster; its desire for a visionary take on the world is perpetually thwarted by its narrow, flattened perspective. Spooked by the *Stain* in the underground parking garage, Waddell knew he had to set himself a new task as an artist. *Dark Matter Atlas* is his burning torch, his attempt to poke out the eye of the Cyclops.

But blinding photography is a futile, quixotic mission: Waddell found himself in the darkness of the caves with a camera rather than a lance or a torch. So he decided to push the limits of his medium. By choosing to shoot in black and white, and to make large-scale prints, Waddell enhanced the ambiguity of the images, giving the viewer more freedom—and more responsibility. There is a history of associating black and white photography with the documentary form and a hard-eyed, coolly accurate view of the world. Yet the inverse is also true: monochrome filters information, inviting the viewer to "colour in" the details.[10] Waddell imbues his caves with a gothic aura, emphasizing the role of the viewer's active apprehension. Further, the large-scale prints create incalculably large spaces for the viewer to enter imaginatively, more shapes and shadows to deal with and interpret. The scale of some of the photographs in *Dark Matter Atlas* matches the scale of encountering that originary *Stain*: these prints aim to conjure the experience of confronting the monster in the underworld. When a viewer encounters a picture at this scale, unglazed, the sheer range of shapes and textures achieves a level of abstraction that hits the viewer's body with the force of a blow to the chest. They experience two orders of information at the same time: a pleasantly uneasy sensation of confusion and engulfment and a simultaneous desire to analyze and comprehend that experience—

the viewer has, as in an actual cave, a heightened awareness of their senses and imagination. Printing at that scale is also a technical challenge for the artist—another way to force himself to achieve something new. (As far as I know, only Hannah Collins, Craigie Horsefield and Jeff Wall have made traditional silver gelatin prints at anything like this scale.)

If caves are gloomy netherworlds, they are also, in *Dark Matter Atlas*, absurd. Look at *Big Room Endgame* (2016): a spooky interior. There, on the ground, a trail of wires and a utilitarian light, as if the whole cave were a Wizard of Oz illusion. What are we to make of that lugubrious ectoplasm in *Onlookers and Wet Stalagmite No.2*? When Waddell depicts this blob of stone the way he does here, it starts to evoke a set of ideas beyond the portrayal of an accretion of minerals. I use the word "ectoplasm" because the picture brings to mind a turn-of-the-century spiritualist photograph of a hazy ghost from the beyond—one of photography's more ridiculous attempts to capture a form invisible to the eye. Yet Waddell can't resist getting up to the same game. With the pictures *Saturn*, *Giant* and *Mouth* (all 2015) he transforms vast columns of stone into expressive spectres, playing with the idea that photography achieves more than a straightforward recording of visible phenomena.[11] This is the abiding tension in *Dark Matter Atlas*: the present, fleshy and material world coexisting with the ethereal and elusive, coloured in by our faulty, freewheeling eyes and mind. What photographer would dare claim that sight—and the camera as its accomplice—reveals anything apart from brute, material facts? Yet who would deny that our minds overflow with monsters at all times, conjured, unbidden, by our imagination? They colour everything we see, not least photographs. We want our perceptions to be accurate, and yet (when it comes to art at least), we want the limits of our vision ripped apart by our imagination—or the imagination of an artist.

Dark Matter Atlas is all the more credible and rewarding as a group of photographs because of its use of humour to address this ambivalence. Look at *Big Room*, *Caveman Autoportrait* (2016) and *King's Palace Twilight* (2016). The complex array of slender stalactites in *King's Palace Twilight* proposes a universe of textural infinity tempered only by the fragment of path that intrudes on the space on the left. Here we have that hint of tidiness that recapitulates the dialectic introduced by the structure of *Stain*: order and irrationality, fact and fancy. Amidst this gothic plenitude, the big "ou-boum" of the meaningless, amoral universe, we spot a well-worn path. The curvy route is also the wry smile of the photographer, acknowledging the limits of his medium. Photography can't capture the infinite or disclose the workings of our unconscious minds. No art can, or not fully. And yet why bother making art without trying? This is the absurd predicament that Waddell captures so vividly with *Dark Matter Atlas*. Even while he longs to illuminate every damp crevasse in the cave of his imagination, and do the same for the viewer, he needs to open the only eye he has: the shutter. In *Big Room, Caveman Autoportrait*, the artist casts a shadow across a bloated stalagmite, so vast and bulbous it must be millennia old. At its peak, natural forms have dripped and hardened into the freakish profile of a dragon or alien. Across its fat base, we see the dark presence of the artist, a shaft rising on his right side. I am flesh and blood, he declares, an ephemeral shadow and a random stain, and here I am, no better than a caveman, a St. George of the disenchanted twenty-first century, lens and tripod instead of a lance, about to confront an ancient, slumbering dragon.

Craig Burnett

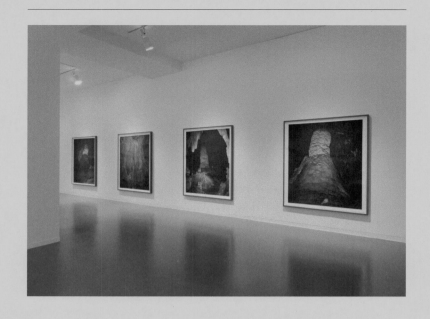

Dark Matter Atlas exhibition (III)
Installation view, Vancouver Art Gallery, 2016

Footnotes

1. Jean Clottes, *What is Paleolithic Art?: Cave Paintings and the Dawn of Human Creativity*, trans. Oliver Y. Martin and Robert D. Martin (Chicago: University of Chicago Press, 2016), 119.

2. Quoted in Hubert Damisch, *A Theory of /Cloud/: Toward a History of Painting*, trans. Janet Lloyd (Stanford: Standford University Press, 2002), 33.

3. The phrase is H.W. Janson's from H.W. Janson, "Chance Images," in *Dictionary of the History of Ideas: Studies of Selected Pivotal Ideas*, ed. Philip P. Wiener (New York: Scribner's, 1973), I:340–53. See also Dario Gamboni's *Potential Images*, an excellent survey of ambiguity in visual art, and where I was introduced to Janson's essay.

4. See for instance the assessment of friend and mentor Jeff Wall, who called him an "outstanding colorist," adding that "Waddell's pictures also have this color-character, which is the mark of a specific and highly individuated view of the world." Jeff Wall, "Off the Radar: Jeff Wall Puts the Spotlight on Stephen Waddell," *Time*, November, 25, 2014, (http://time.com/3595580/off-the-radar-jeff-wall-puts-the-spotlight-on-stephen-waddell/).

5. Paolo Uccello, *Saint George and the Dragon*, c. 1470, oil on canvas, 55.6×74.2 cm. National Gallery, London, Bought with a special grant and other contributions, 1959 (NG6294), photo © National Gallery, London/Art Resource, NY.

6. Giovanni Bellini, *Saint Jerome Reading*, 1505, oil on panel 47×37.5 cm. National Gallery of Art, Washington, Samuel H. Kress Collection, 1939.1.217.

7. Lu Zhi, *The Jade Field*, 1549, Ming Dynasty, ink and color on paper, 24.2×136.1 cm. The Nelson-Atkins Museum of Art, Kansas City, Missouri, Purchase: William Rockhill Nelson Trust, 50-68.

8. Gustave Courbet, *Grotto of Sarrazine near Nans-sous-Sainte-Anne*, c. 1864, oil on canvas, 50.2×60 cm. J. Paul Getty Museum, 2004.7. Digital image courtesy of the Getty's Open Content Program.

9. Robert Bresson, *Mouchette*, 1967, film, black and white, 78 minutes. © 1967 Argos Films—Parc Film.

10. I make this argument in *Jeff Wall: Black and White Photographs, 1996–2007* (London: White Cube, 2007).

11. It's important to note here that all the photographs in *Dark Matter Atlas*, distinct from most of his work in colour photography, are straight: shot on film, processed and printed without any digital manipulation.

List of Works
Stephen Waddell: Dark Matter Atlas

1. *Entrance* (2016), silver gelatin photograph, 106×133.5 cm (41.75×52.5 in)
2. *Ranger Laura* (2016), silver gelatin photograph, 133×106 cm (52.25×41.75 in)
3. *Understudy* (2015), silver gelatin photograph, 128×101 cm (50.5×40 in)
4. *Portrait Bust* (2015), silver gelatin photograph, 101×127 cm (39.75×50.5 in)
5. *Motorcyclist* (2015), silver gelatin photograph, 105×132 cm (41.5×52.25 in)
6. *Standing Portrait* (2014), silver gelatin photograph, 159×126 cm (62×50 in)
7. *Stain* (2012), silver gelatin photograph, 152.5×124.5 cm (60×49 in)
8. *Kammerspiele* (2016), silver gelatin photograph, 126×99.5 cm (49.5×39.25 in)
9. *La Grotta dei Lamponi (After Henry Darger)* (2015), silver gelatin photograph, 127×157 cm (50×62 in)
10. *Jeita Grotto* (2015), silver gelatin photograph, 99×125.5 cm (39.25×49.375 in)
11. *Onlookers and Wet Stalagmite No. 1* (2016), silver gelatin photograph, 81×69.5 cm (34.5×27.375 in)
12. *Cave* (2016), silver gelatin photograph, 126×99.5 cm (49.5×39.25 in)
13. *Burden of Form* (2016), silver gelatin photograph, 100.5×128 cm (39.5×50.25 in)
14. *Theatre* (2016), silver gelatin photograph, aluminum substrate, 126×156 cm (49.5×61.375 in)
15. *Buddha Horn Lake* (2016), silver gelatin photograph, 101×128 cm (39.75×50.25 in)
16. *Baldacchino* (2016), silver gelatin photograph, 118×147 cm (46.5×57.75 in)
17. *Kings Palace Twilight* (2016), silver gelatin photograph, aluminum substrate, 126×156 cm (49.5×61.375 in)
18. *Big Room at Dusk* (2016), silver gelatin photograph, aluminum substrate, 260×329 cm (102×130.375 in)
19. *Big Room, Caveman Autoportrait* (2016), silver gelatin photograph, aluminum substrate, 292×368 cm (115.375×145 in)
20. *Big Room Endgame* (2016), silver gelatin photograph, aluminum substrate, 304×376 cm (119.75×148 in)
21. *Column* (2015), silver gelatin photograph, 162×132 cm (64.5×52.25 in)
22. *Giant* (2015), silver gelatin photograph, 162×133 cm (64.75×52.25 in)
23. *Cascade* (2016), silver gelatin photograph, 164.5×133.5 cm (64.75×52.5 in)
24. *Saturn* (2015), silver gelatin photograph, 164.5×133 cm (64.75×52.375 in)
25. *Veil* (2016), silver gelatin photograph, 164.5×133.5 cm (64.75×52.5 in)
26. *Peter in Chains* (2015), silver gelatin photograph, 162×132 cm (64.5×52.25 in)
27. *Mirror Lake* (2016), silver gelatin photograph, aluminum substrate, 179×222 cm (70.5×87.375 in)
28. *Mouchette, Queen's Chamber* (2015), silver gelatin photograph, 130×160.5 cm (51.25×63.25 in)
29. *Mouth* (2015), silver gelatin photograph, 160.5×129.5 cm (63.25×51 in)

Postscript
Stephen Waddell: Dark Matter Atlas

Over the past two decades Stephen Waddell has become widely known for his large-scale colour photographs that depict the human figure in urban space and consciously embrace the ambiguous territory between spontaneity and deliberation, objective document and personal expression.

Dark Matter Atlas presents a body of recent photographs in which Waddell has departed dramatically from the subject matter of his earlier work by focusing on underground caverns in the United States, Canada and Lebanon, spaces once inaccessible to the public that are now tourist attractions. Printed to a large scale on traditional black and white photographic materials, Waddell's surreal and compellingly beautiful pictures expand upon conventional conceptions of landscape and recall a varied set of episodes from the modern era, ranging from Nadar's 19th century photographs of the catacombs beneath Paris, through the photographs Constantin Brancusi made of his studio in the 1920s and 30s and Max Ernst's Surrealist depictions of Europe in ruins during the Second World War, to photography's inherent ability to bring us images of exotic or distant places we will never see in person. The fantastic nature of the caverns, and the evocative forms of the stalactites and stalagmites that fill them, find an uncanny echo in the accompanying pictures of late-Renaissance marble sculpture or the more prosaic mineral deposits left by leakage in the parking garages that lie just below the surface of the contemporary urban environment.

The cavern photographs are the result of a complex and often arduous process of obtaining permission to work in the caverns and hauling the required photographic equipment to the chosen viewpoint, which can be more than 1,000 feet below ground. While it may seem that Waddell is showing us what these spaces look like, their appearance here is determined as much by the mechanisms of photography—lighting, camera, lens, film and photographic paper—as the physical form the caverns have taken over eons of geological time.

This exhibition was made possible with the generous support of our Presenting Sponsor, Rogers Communications Inc., and its Vice-Chairman and Gallery Trustee, Phil Lind. I'm also extremely grateful for support from Jane Irwin and Ross Hill. My heartfelt thanks go to Miles, Maureen and Larry Lunn, our Visionary Partner for Photography Exhibitions, and to David Aisenstat, the Gallery's Visionary Partner for BC Artist Exhibitions. I very much appreciate the assistance of the Monte Clark Gallery in Vancouver, which has been essential to the presentation of the exhibition. In addition I would like to thank the Board of Trustees and staff of the Vancouver Art Gallery for their exceptional work and support of all aspects of this exhibition. Special mentions go to Grant Arnold, Audain Curator of British Columbia Art, for his stewardship in bringing on this project to fruition and to Craig Burnett for his insightful text on Stephen Waddell's practice.

This book is aided by the Richardson Family, our Visionary Partner for Scholarship and Publications. My appreciation also goes to Henrik Nygren for his excellent design for this publication and to our Berlin-based co-publishers Distanz for taking the book on.

Finally, of course, my heartfelt appreciation goes to Stephen Waddell for this singular and most compelling body of new work.

Kathleen S. Bartels, Director

Acknowledgments

Dark Matter Atlas the exhibition would have remained under cover of darkness if not for the invaluable support of Vancouver Art Gallery Director Kathleen Bartels. I am indebted to Grant Arnold for offering his precise curatorial hand through all stages of *Dark Matter Atlas*. To Kathleen, Grant and Daina Augaitis I express my gratitude for encouraging and realizing the acquisition of *Dark Matter Atlas* works for the Vancouver Art Gallery collection. The very idea of making a publication for this exhibition represented a chance to work with Henrik Nygren from Stockholm and I thank him sincerely for his poetic design and introduction to the possibilities of printing in Sweden. I would like to thank Keun Kim Roland for bringing the form of this book together and Håkan Bergström at Göteborgs-tryckeriet for the exceptional printing. Thanks to Craig Burnett for recommending that I witness first-hand *The Ambulatory of the Great Hunt* in the Villa Romana del Casale, Sicily and most especially for writing *Underworlds*. Thanks to Bruce Wiedrick for managing this publication into being, to Rachel Topham and Trevor Mills for documenting my exhibition and to Danielle Currie for arranging the image requests. Making photographs in caverns and grottos often requires permission from helpful park rangers and people like Dr.-Eng. Nabil Haddad, General Manager of Jeita Grotto, Lebanon and Paul Cox, Program Manager, Carlsbad Caverns, Carlsbad, New Mexico. Printing and mounting these pictures was never easy but a sincere thanks to Mike Grill for his tireless help. Over the last few years there have been a number of people I have relied upon either in the making of this exhibition or the working and idling that led up to *Dark Matter Atlas*. Graham Dalik, Steffanie Ling, Roy Arden, Aaron Peck, Helga Pakasaar, Felix Rapp, Adrian Buitenhaus, Abbi Newfeld, William Cupit, Alyssa Dusevic, Faber Neifer, Sean Wallish, Matthew Shields, Madison Killough and Nicole Kelly Westman. Having an artist in the family can be a burden so to Isabel, Oscar, August and Rosalie I want to thank you for being sublime.

I would like to acknowledge the generous support of Claudia Beck and Andrew Gruft, Jane and Ross Hill, Naila Kunigk-Kettaneh/ Galerie Tanit, Monte Clark / Monte Clark Gallery and Jeannette and Jeff Wall.

It is a tremendous opportunity to be able to publish this book and I would like to express my gratitude to Stephen Fitterman, The Michael O'Brien Family Foundation, Bruce Wright, Monte Clark and Robin Vousden for their invaluable sponsoring of this book.

Stephen Waddell, biography

Stephen Waddell, born 1968, lives and works in Vancouver, where he received his MFA from the University of British Columbia. His photographic approach adheres to the hunting and gathering model of direct photography, yet his intention is not documentary or journalistic, but rather is rooted in the tradition of Realism. Major solo exhibitions include Einwohner/Inhabitants (Kunstforum Baloise, 2012), Stephen Waddell (Contemporary Art Gallery Vancouver, 2008), and Talents 03 (C/O Berlin, 2006). Waddell has published several books of his work, including *Hunt and Gather* (Steidl, 2011) and *Stephen Waddell* (Contemporary Art Gallery, 2008).

Published in conjunction with the exhibition *Stephen Waddell: Dark Matter Atlas* organized by the Vancouver Art Gallery, curated by Grant Arnold and presented from June 11 to October 30, 2016.

Exhibition curator: Grant Arnold, Audain Curator of British Columbia Art
Curatorial assistant: Siobhan McCracken Nixon
Essay: Craig Burnett, *Underworlds*
Editing: Emma Conner and Meaghan McAneeley
Photography: Trevor Mills and Rachel Topham
Rights and reproductions: Danielle Currie
Production: Henrik Nygren Design
Paper: Colorit Graphite Grey, Arctic Volume Ivory, Colorit Flamingo Pink and Colorit Misty Grey
Printed: Göteborgstryckeriet, Sweden, 2017

Back cover: André Breton, *Nadja*. Originally published in 1928 by Librairie Gallimard, Paris, France

Publication support

Visionary Partner for Scholarship and Publications:
The Richardson Family

Monte Clark
Stephen Fitterman
Michael O'Brian Family Foundation
Robin Vousden
Bruce Wright

Exhibition support

Presenting Sponsor:

Generously supported by:
Jane Irwin and Ross Hill

Visionary Partner for BC Artist Exhibitions:
David Aisenstat

Visionary Partner for Photography Exhibitions:
Miles, Maureen and Larry Lunn

The Vancouver Art Gallery is a not-for-profit organization supported
by its members, individual donors, corporate funders, foundations,
the City of Vancouver, the Province of British Columbia through the
British Columbia Arts Council and the Canada Council for the Arts.

Vancouver
Artgallery

Vancouver Art Gallery
750 Hornby Street Vancouver, BC, Canada V6Z 2H7
www.vanartgallery.bc.ca

Distribution:
Gestalten Berlin
www.gestalten.com
sales@gestalten.com

ISBN 978-3-95476-184-5 [DISTANZ Verlag]
ISBN 978-1-927656-29-7 [Vancouver Art Gallery]
Printed in Sweden

Published by:
DISTANZ Verlag
www.distanz.de